Phil O'Connor's

21 years of cycling photography

Phil O'Connor's
21 years of cycling photography

Prologue by Phil Liggett

Introduced by Luke Edwardes-Evans

Wheelmark Publishing
Telford Road, Bicester, Oxon OX26 4LQ, UK

Published by Wheelmark, an imprint of

Speechmark Publishing Ltd, Telford Road, Bicester, Oxon OX26 4LQ, UK

First Published 2003

Printed in Malaysia

Book design in conjunction with Stuart Winfield, Lighthouse Design, Brackley, UK

Colour separation by Lithomatic Sdn. Bhd, Malaysia

Marketing by Sport & Publicity, 75 Fitzjohns Ave, London NW3 6PD, UK

British Library Cataloguing in Publication Data

O'Connor, Phil

 Phil O'Connor's 21 Years of Cycling Photography

 1. O'Connor, Phil 2. Bicycle racing – Pictorial works

 3. Photography, Artistic

 I. Title

 779.9'79662'092

ISBN 0 86388 504 7

Acknowledgements

Tony Bell for his input at the beginning of this project; Richard Allchin for his endless support, love of cycling books and the sport; Luke Edwardes-Evans for his constant enthusiasm for photography, publishing and a sport which we have both enjoyed for many years; Ian Franklin for publishing this book; *Cycling Weekly* and *Cycle Sport* magazines for never questioning my expenses; Sporting Pictures (UK) Ltd for four very rewarding years – the money was lousy but I learnt loads and it was always a laugh; Ken Williams of the Bournemouth Arrow Cycling Club and John Smith of the Addiscombe Cycling Club – sadly neither of these gentlemen are with us any more but both, through their sheer enthusiasm for the sport, helped to create my future relationship with cycling; and finally . . . to the riders, the bit-part players in all of these images, without whose dedication the sport would not exist.

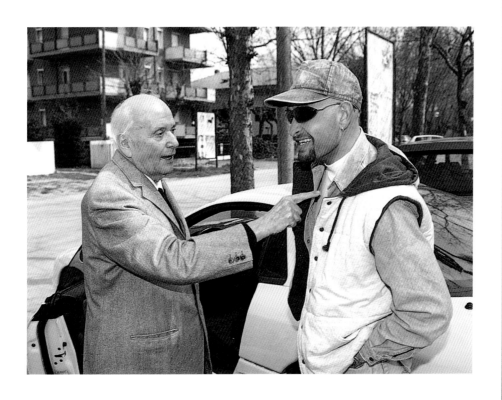

Marco Pantani, Censenatico, 1996. This was taken whilst spending a day with Marco. He was recovering from his compound leg fracture and had begun light training. As ever when he left his house there would be a group of people to greet him and get his autograph. When we left for a short training ride a group of German cyclists, who were staying in town, presented him with a bottle of wine and wished him well for his recovery. This photo was taken when we went for a walk after his ride. No doubt this local old boy was imparting some pearls of wisdom which Pantani graciously accepted.

Phil O'Connor's first picture was published in *ProNews* in 1981. Between 1982 and 1988 he worked as a freelance photographer supplying pictures to *Cycling Weekly, Cyclist Monthly, Winning, Bicycle Magazine, Velo News, Bicycle Action* and *Bicycling*. This was followed by four years as a staff photographer with Sporting Pictures (UK) Ltd where he covered major cycling events including the Olympics, the world championships and the Tour de France. In 1992 he returned to the world of freelance photography and he now has exclusive contracts with *Cycling Weekly* and *Cycle Sport*.

Dedication

To my wife Nina without whom the photographs in this book could never have been taken.

Prologue

Phil Liggett

It is true when it is said that every picture is worth a thousand words, although many journalists would argue their case. However, the sport of cycle racing is most vividly revealed by the skill of the eye as the artisans of one of the hardest sports produce images which have few rivals.

Cyclists, be they the humble club rider aiming to impress his girl friend, or the Tour de France winner more intent on improving his bank account, for both one thing is the same. In a word, **pain**! There is no easy way to win a bike race and no finer attraction to a skilled photographer, who uses his skills to capture the moments that lead to success or glorious failure. Phil O'Connor is at the top of his profession and his portfolio has few equals. He understands what is needed because he has been both a cyclist and an athlete. Still is, in fact, although the pain may be a little less concentrated these days.

For 22 years I directed the Milk Race, a wonderful racing tour of Britain every springtime. Phil's pictures of Frenchman Philippe Casado, tough Irishman Sean Kelly, and the British riders Malcolm Elliott, Chris Lillywhite and Steve Joughin, all bring back fond memories of men who impressed on their way to long and successful careers. Sadly, Philippe died while playing rugby soon after he retired from competition and this photograph will remain a poignant memory of one of his rare visits to a British race.

I never tire at looking at the images by those fortunate enough to be in a position to freeze the moment. It is all over in a second, but if you get the shot, it stays with you for the rest of your days. Phil O'Connor has got the shots and, like you, I will enjoy this trip down memory lane, adding my own memories to those who know that in cycling, there is never gain without pain.

Phil Liggett
Hertfordshire 2003

Introduction

Luke Edwardes-Evans

If you have ever taken a photo of a racing cyclist, and we have all tried it at one time

or another, you will have a good idea of how difficult it is. Getting the subject in focus

as you swivel round and release the shutter as the rider flashes past takes a good eye,

co-ordination and nerve. On a quiet stretch of road you might get a nice photograph of

a single rider but add a barrier, a thousand screaming fans, team cars, motorbikes

and a bunch of 150 riders and your success rate may start to suffer.

Disappointment follows when you inspect the images only to discover that an elbow has

appeared in one, a car in another and a lamp-post is sprouting from the head of the one clear

image of a rider that you grabbed in that intense little moment as the race rushed by. Nagging

you too, is a feeling of regret that you decided to record the moment in an impassive, objective

way, thereby passing up the opportunity to let out a cheer or a shout of encouragement. Maybe

you could have caught a rider's eye or done something, however small and insignificant, that

gave you a supporting role in the unfolding drama of a bike race.

If that bike race was an international event with professional riders your amateur efforts will be

cruelly exposed when you open the pages of your favourite cycling magazine and eagerly

turn to the report of the race at which you were present. You'll see pin-sharp photos of the peloton riding through an idyllic scene typical of the race, action photos of the champions and winners, dramatic crashes and revealing portraits. These so outclass your roll of prints in their range of coverage and quality of reproduction that you vow that from henceforth you will leave it to the experts and instead just yell your head off next time. Your friends will silently thank you when you stop showing them your dog-eared snaps.

This book is by one of those rare and lucky people – a great photographer who loves cycle racing. Phil O'Connor was a cyclist before he took up photography but early on he understood that to get the best results he would have to live in the lens, rather than in the moment of the race. He knew he would have to separate himself from the crowd, to view them as a colourful, though often unpredictable, element of the scene in his viewfinder. Now that is not as easy at it sounds because cycle racing is like no other in the challenges and obstacles it presents to the professional photographer.

Oh for the cordoned-off touchline roamed by the stadium photographer. Or the leisurely timetable of the golfing or horse race snapper. The cycling photographer might just get a pitch on the finish line of a big race. Here he'll have to jostle with colleagues, dodge cars and motorbikes as they scream through the narrow barrier-lined space and finally get a split second chance to record the moment as the winner's front wheel touches the white line at 45mph. Most of the time, however, he'll have to stand at the side of the road like everyone else, lean out a bit further, and brush elbows with fans and riders alike. Add every type of weather, a six-hour race

In 1981 I cycled to the top of the Col de la Ramaz and was rewarded with my first view of Bernard Hinault (left). Using Kodachrome this was the first time I had captured the Tour in all its glory. Little did I know that I was starting out on a voyage that would see me return to the top of this climb 21 years later when, using digital technology, the cycling journalist Richard Hallett took this picture of me (below) on the same stretch of road.

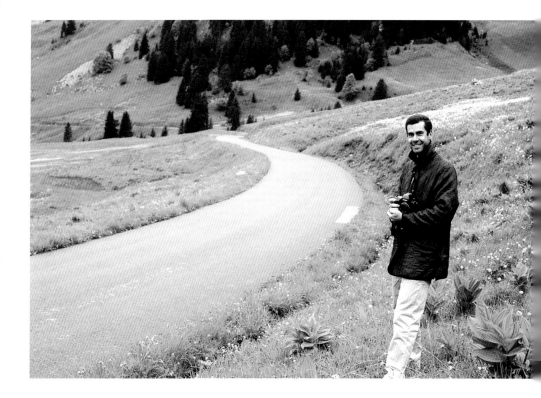

and the logistics of getting from one end of the course to another by motorbike or car, and you get an idea of a day in the life of Phil O'Connor.

Behind every image in this book are 21 years of days-in-the-life for Phil, whose energy, determination and resourcefulness have resulted in this dazzling variety of shots. Not every 250th of a second is the result of a one-man battle against the world. Indeed, many are taken in beautiful locations that make the job look like an ultimate jolly trip. A scenic view of snowcapped mountains with the Tour peloton toiling away on the road below as late afternoon shadows form a wake behind each rider might look like a simple composition, but behind a Tour de France shot like this there is a serious amount of work.

If you are not one of the favoured few who get to accompany the Tour on the back of a motorbike then you have to use a car and drive for miles every day, stopping maybe twice for the opportunity to take photos. That's at least 100 miles per day of potential locations where you must decide on type of shot – action or scenic – a suitable background and the potential for invariables like the crowd and the weather. It's a creative process, it's also quite nerve wracking and certainly tiring. If Phil has ever shouted at you or your elbow, don't take it personally, you probably just ruined his whole day.

In 21 years it would be surprising if there was not a variety of races, places and faces in this book. The fabulous range of Phil's cycling subjects is not only testimony to his enthusiasm and his love of all branches of the sport, it's a truly unique record in photos of more than two decades of cycling history. True, there's a UK and an English-speaking perspective which

largely reflects the magazines and books that he's worked for, but as the 1980's and 1990's were decades in which the non-traditional cycling nations changed the face of world cycling that is no bad thing.

Enjoy the photos for their drama and beauty, and maybe with an appreciation for the thought and graft that went into getting them. But above all, enjoy them for their vitality and humanity. From the humblest amateur sitting in the bath with a dirty face and bottle of champagne to the super-champion risking his life on an alpine descent, these photos are a celebration of the greatest of all sports and the mortal heroes that we cheer on at the top of our voices.

Allez!

Whilst camera technology may have changed considerably over the past 21 years, the bicycles that the riders race on have gone through an even greater revolution. The time trial bike used by Sean Yates (left) in 1985 is a fairly standard machine. Fifteen years later and the machine used by Lance Armstrong (right) is from another age altogether. Every part has been changed in either the design or in the materials used. However, despite all of these innovations the best rider still wins!

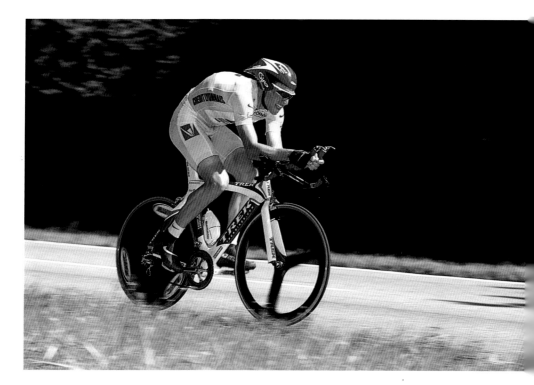

Below: **Milk Race, Bournemouth, 1981**
This picture is an important personal milestone for
me. Although it is not the first picture I have had
published, it is the earliest of my pictures to be
published. Great Britain's Steve Joughin won the
stage from team mate Mark Bell, a last minute
inclusion in the team, along with fellow Merseysider
Phil Thomas. Taken in the days when the Milk Race
was dominated by anonymous riders from Eastern
Europe and the Soviet Union, any British success
was a treat, as the outstretched arms of Joughin
and of the fan on the left shows.

Right: **Jonathan Boyer, Tour de France,
1981** Well, this is just an ordinary picture of
Jonathan Boyer right after the start of the Mulhouse
time trial at the 1981 Tour de France. Little did I
realise as I clicked the shutter on my Nikkormat that
this would be the first of my photographs to be
published. It was used in a magazine called
ProNews, now long defunct, but at the time was a
large format magazine with a radical campaigning
edge.

Far right: **Manx International, 1996** Every
year I would follow this race on a motorbike and
every year I would be too late to take this picture as
we zoomed past the spot at 70 mph! Eventually I
remembered in time and was able to capture the
beauty of the Isle of Man, something that the riders
probably do not notice. The picture is taken at the
top of the mountain, Snaefell. The riders in the
International have to tackle the six-mile climb three
times in the 113-mile race, and anyone who has
ridden up it will tell you that once is enough. Beyond
the hills is the Irish Sea and beyond that is Cumbria
in northwest England. If you look closely on the
right of the picture you can see the railway line that
snakes its way to the top of the mountain from
Douglas. Belfast's David McCann in the green and
white jersey won the race. As it was Olympic year,
the Australians used the race as the selection race
for the Atlanta road squad. Here you can see Robbie
McEwan trailing Ireland's former Tour de France and
Giro d'Italia stage winner Martin Earley, who also
went to Atlanta to ride the mountain bike race.

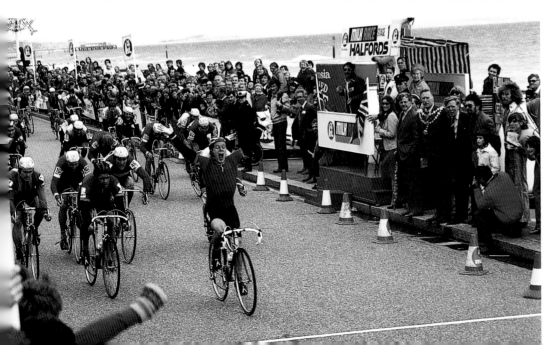

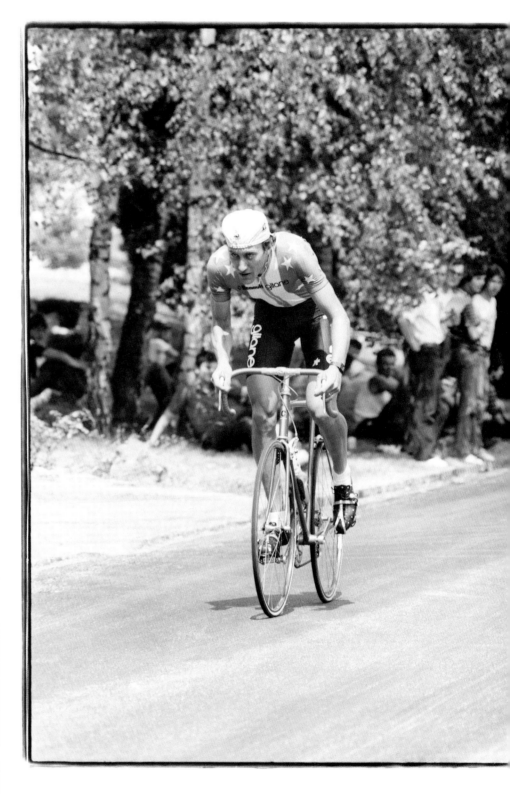

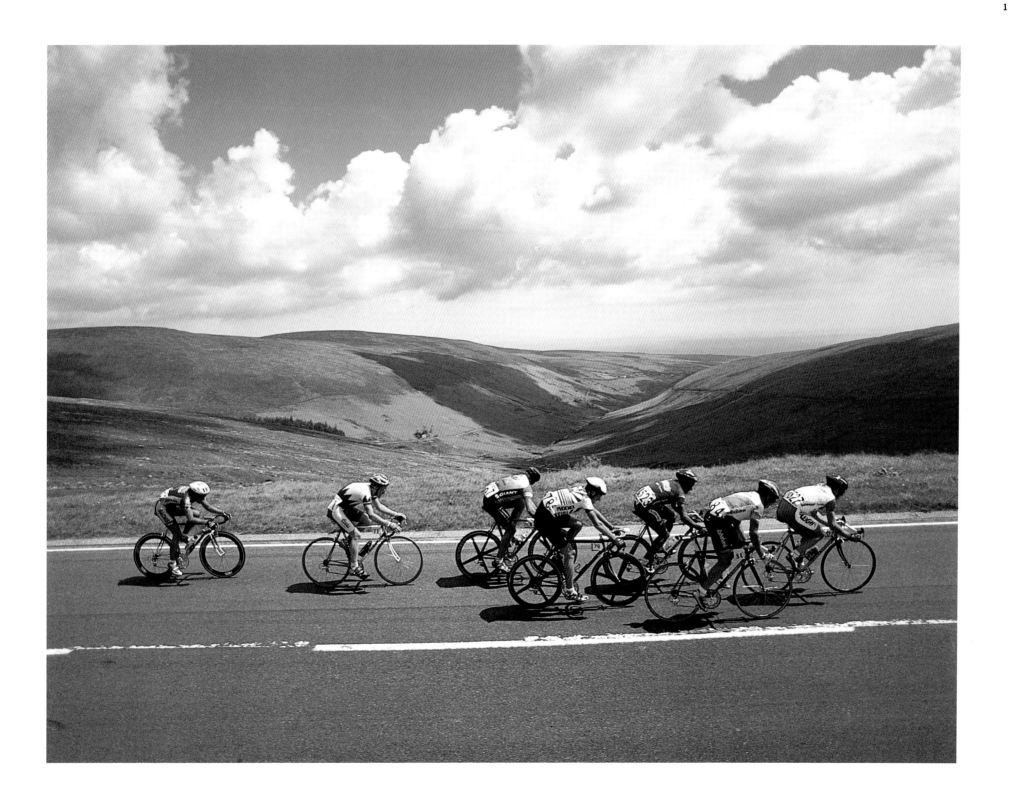

Left: **Pedro Delgado & Stephen Roche, Tour de France, 1987** You could write an entire book about this Tour alone as so much happened. It was always exciting. At this point the yellow jersey of Jean-François Bernard is in trouble because of a puncture. These two have gone ahead both no doubt sensing this as the moment when they could go on to win the Tour. Ultimately it was to come down to a straight fight between them but not without a few twists and turns along the way.

Right: **Pedro Delgado, Tour de France, La Plagne, 1987** This was Delgado's first day in yellow after taking it from Stephen Roche at the top of the climb of L'Alpe d'Huez. Here he is looking across the valley to see how much time he has put into Roche. This picture was taken with about 5kms to go. What followed was extraordinary as Roche closed the gap to a few seconds by the finish line to keep his winning chances alive. It was a memorable moment in Tour history and Phil Liggett's unmistakable commentary on Channel 4 helped to cement the event into our consciences for ever.

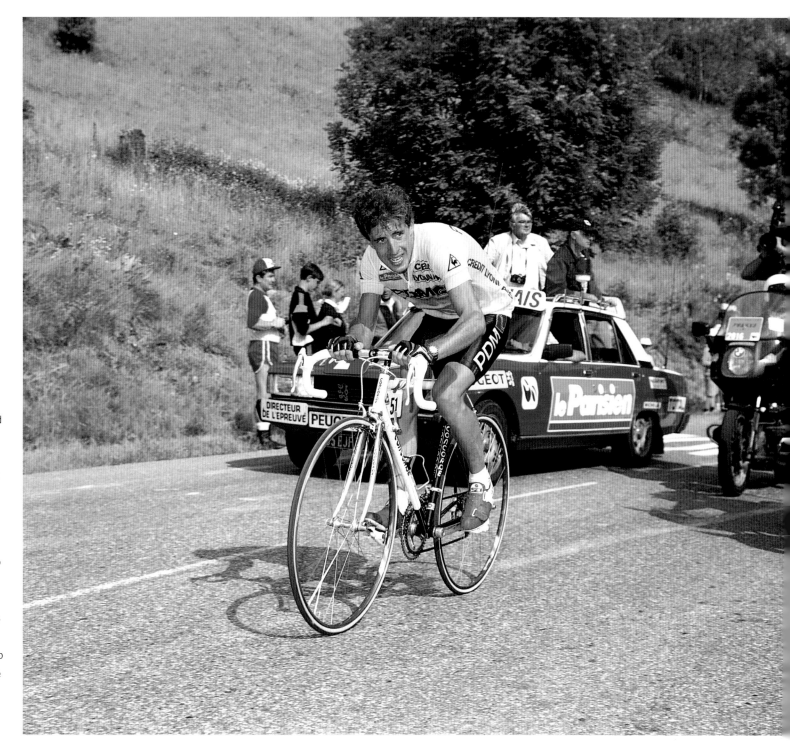

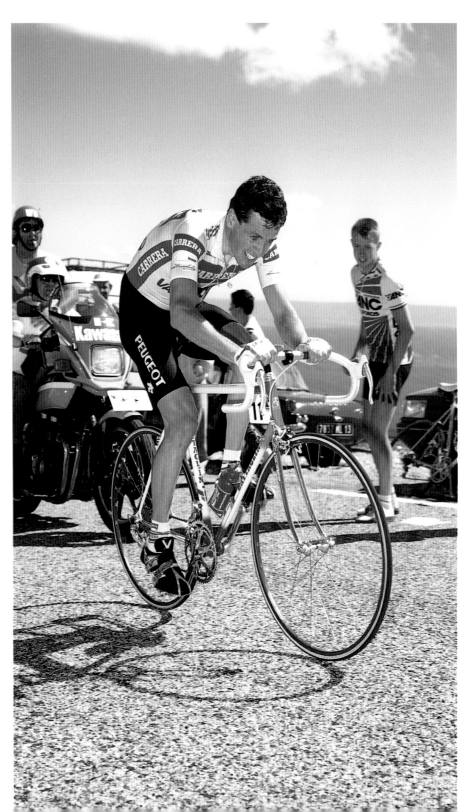

Left: **Stephen Roche, Tour de France, Mont Ventoux time trial, 1987** The 1987 Tour will always be remembered for the battle between Roche and Pedro Delgado, with the jersey swapping between the two before Roche finally claimed it. Here the Irishman is suffering against the clock on the slopes of Mont Ventoux. The spectator wearing the ANC jersey at the side of the road is Lee Travis, who at the time was a promising young British rider.

Above: **Stephen Roche, Tour de France, 1987** This was the Irishman's first day in yellow. Here he is seen really suffering as he digs deep to reduce his losses to Pedro Delgado who is making a bid for overall victory. Roche had taken the lead the day before when he joined Delgado in an audacious attack which ended France's Jean-François Bernard's tenure on the yellow jersey when he punctured. At the end of the day the jersey was to move from Roche to Delgado, but this was only temporary.

Right: **Stephen Roche & Jeannie Longo, Tour de France, 1987** The final stage in Paris and it seems that the population of Ireland is in town. I positioned myself in front of a huge U2 banner that someone was carrying and Roche turned and waved on queue. A small gap between motorcycle outriders allowed me to take this picture.

Far right: **Stephen Roche, Tour de France, Dijon time trial, 1987** Here Roche rides back into yellow by displacing Pedro Delgado in the final time trial. It was the last move by the Dublin man to take the jersey in what was to be one of the most memorable Tours of all time. Jean-Françoise Bernard won the stage which might explain why the crowd appear to be a bit muted in response to Roche's efforts.

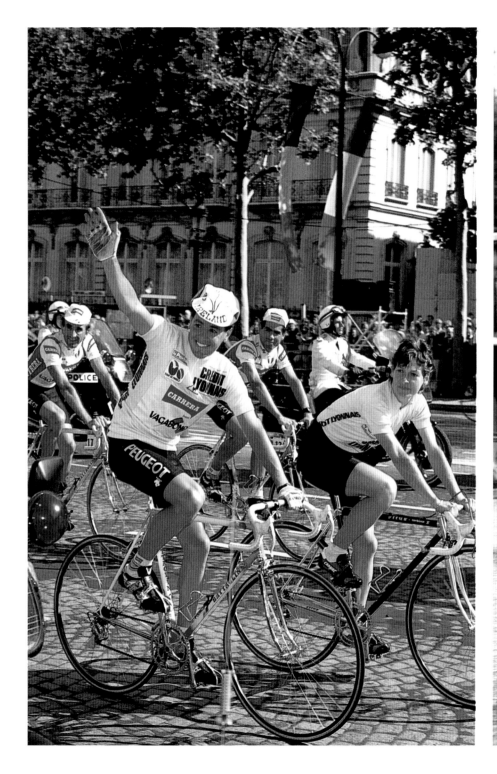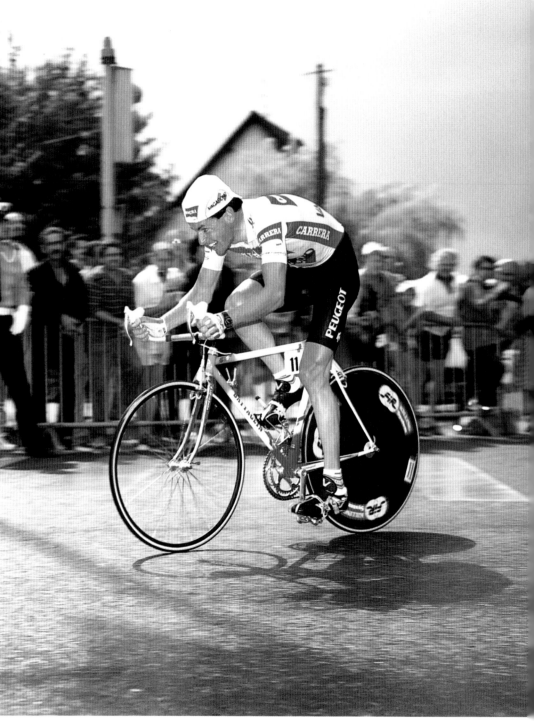

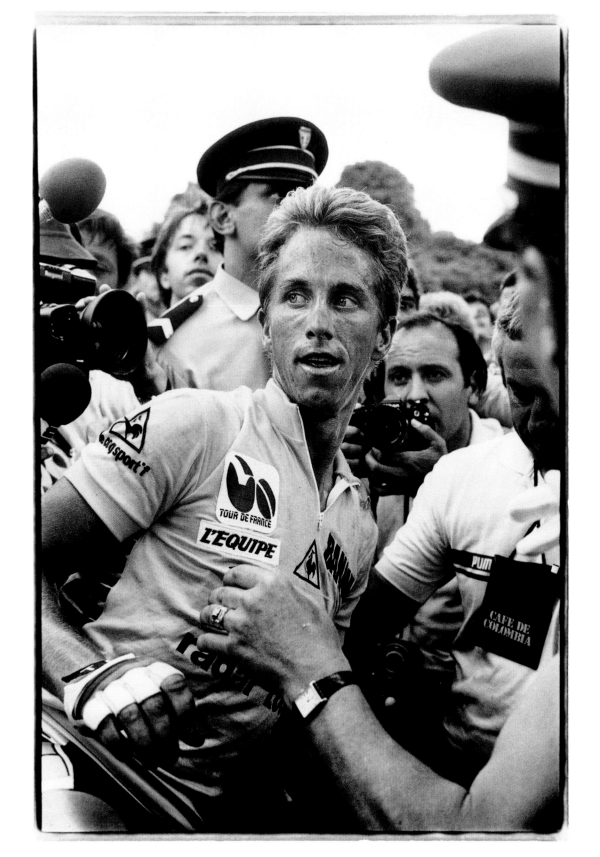

Left: **Greg Lemond on the Champs Elysées,
1986** This was after the famous duel with Bernard
Hinault. I got lucky with this photo as he rolled to a
stop just in front of me with that young immortal
look in his eye. Two seconds later I was bundled
into touch by a large group of photographers and
TV crews. Up until recently it had been open season
on the world's best cyclists for cameramen and
photographers; the access afforded to all of us is
infinitely better than in so many other sports. The
thing I love about this photograph is his jersey. It
seems light years away from today's jerseys. Here
is the "Golden Fleece" with sponsors' logos sewn on
and other logos as black flocking.

Right: **Greg Lemond, Tour de France,
prologue, Fontenay-sous-Bois, 1984**
Lemond is wearing the rainbow jersey he won at the
world championship the previous August. Look at
the bikes the riders were using in time trials in
those days. Cyrille Guimard, who managed the
squad, was very keen to try out the latest technical
innovations.

Overleaf: **Greg Lemond & Bernard Hinault,
Tour de France, l'Alpe d'Huez, 1986** This
was one of the most memorable days in the Tour's
history. Here two team mates are locked in a grim
battle of wills and minds. The team was split about
whom it should ride for. It was a seminal moment in
that for the first time an English-speaking rider was
looking likely to win the race. Ultimately they
crossed the line together hand-in-hand but few
doubted that they were really close friends. History
shows that Lemond went on to win the Tour that
year but in reality he won a number of unseen
battles during the race. After the race Hinault found
it hard to praise the American saying he had not
won the race with 'panache'.

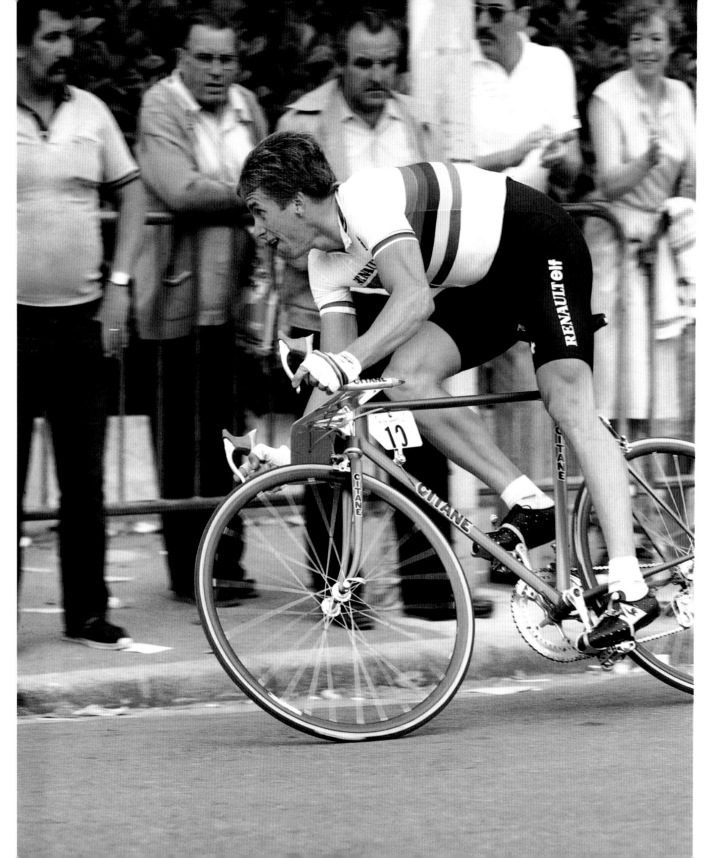

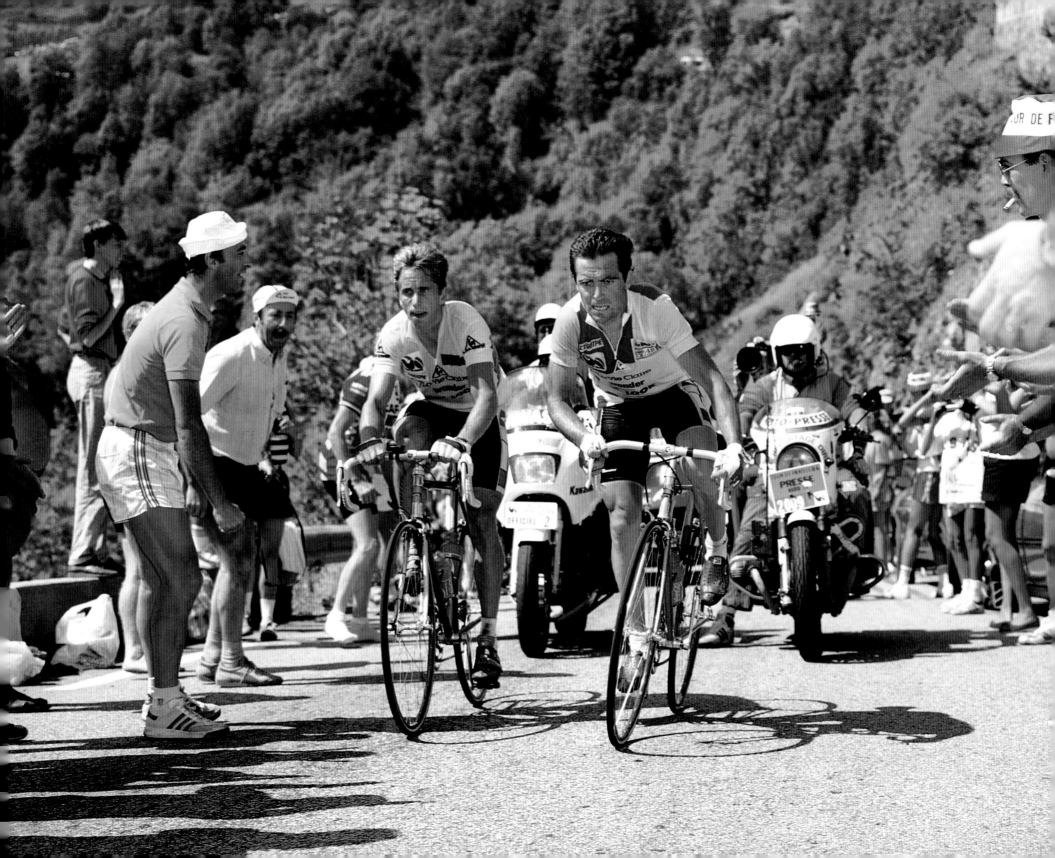

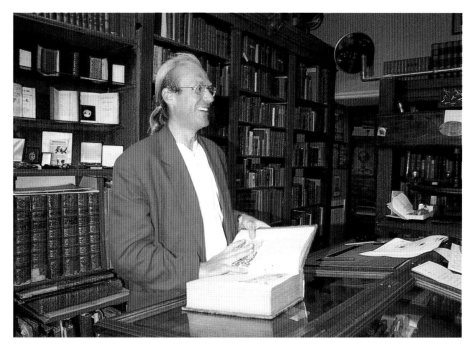

Above: **Laurent Fignon, Paris bookshop, 1992** Fignon was known as 'The Professor', due to his studious demeanour. Along with writer William Fotheringham, I spent a day in Paris with the double Tour winner. After we had spent a while in this antiquarian bookshop we had a meal and then Fignon asked if there were any other pictures I would like to take. I went for the obvious choice, a shot on the Eiffel Tower with Paris as a backdrop. It was at this point that we discovered Fignon suffers from vertigo and, despite being a Parisian, he had never been up the Tower. But like a true pro, he agreed to the request. After taking a deep breath, he stared hard at the floor of the lift on the way up. Once at the top, he edged up to the handrail which he held for a few seconds whilst I took a few pictures, then dashed back into the safety of the lift. Merci Laurent!

Right: **Laurent Fignon, Tour de France, prologue, Fontenay-sous-Bois, 1984** Fignon had been the surprise winner of the 1983 Tour when Bernard Hinault did not ride. There was much speculation as to what would happen when these two would go head to head in the Tour. He won again.

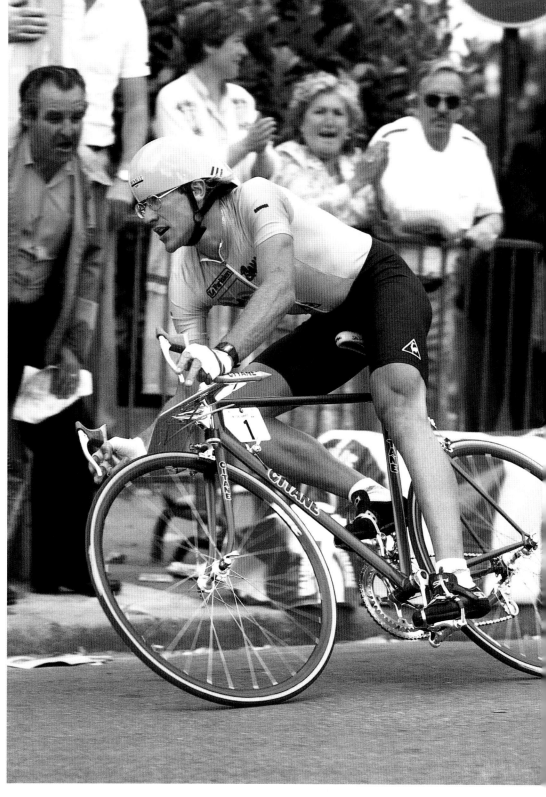

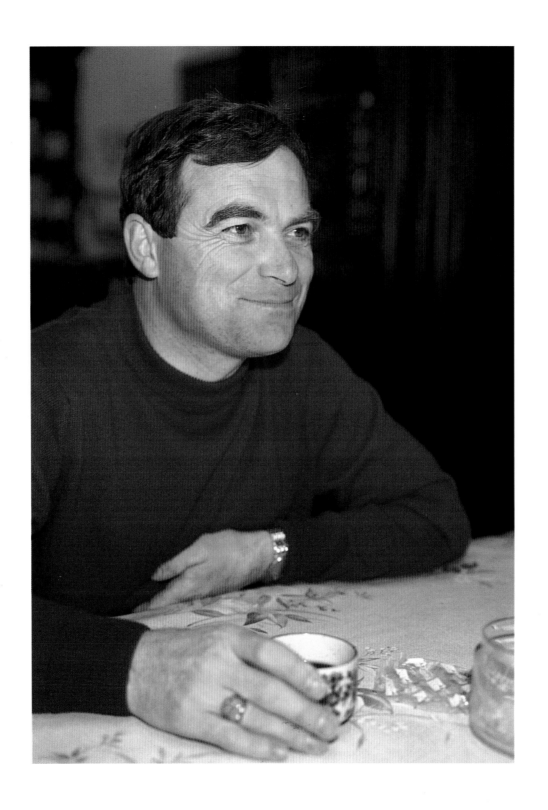

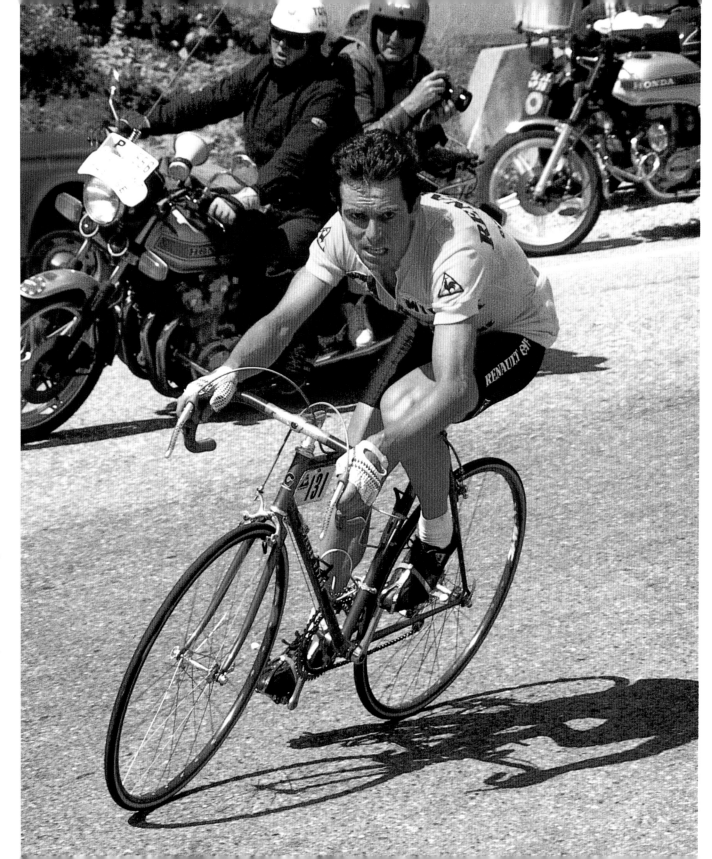

Left: **Bernard Hinault at home** I went to photograph him in 1993 at his farm in Yffiniac in Britanny for a feature in *Cycle Sport* magazine. He made me a cup of tea!

Right: **Bernard Hinault, Tour de France, Le Pleynet, 1981** This was Hinault at his best, attacking to win this alpine summit finish alone. The man who was known as 'le Blaireau' ('The Badger') had a point to prove having pulled out of the Tour the previous year while wearing the Maillot Jaune. A knee injury was responsible and while this allowed Joop Zoetemelk to finally win the Tour after eleven years of trying, there was a question mark over Hinault, who had won in 1978 and 1979. The manner of his victory in this race, and in the following year's Tour, proved that badgers are indeed dangerous animals when cornered.

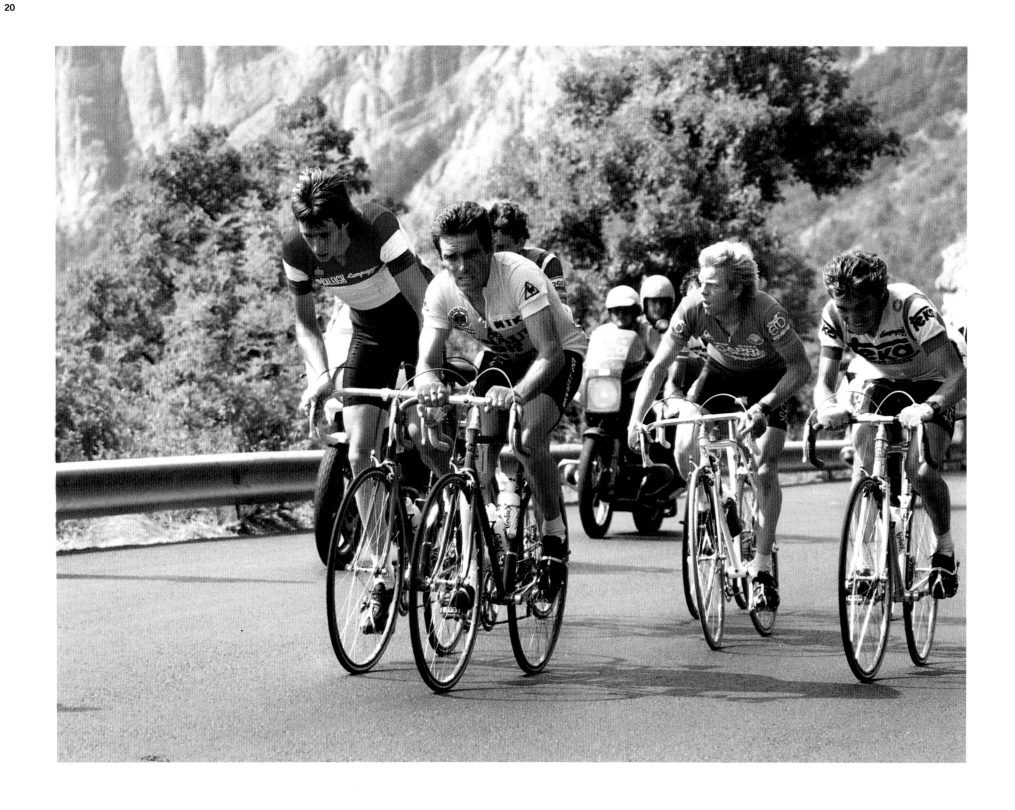

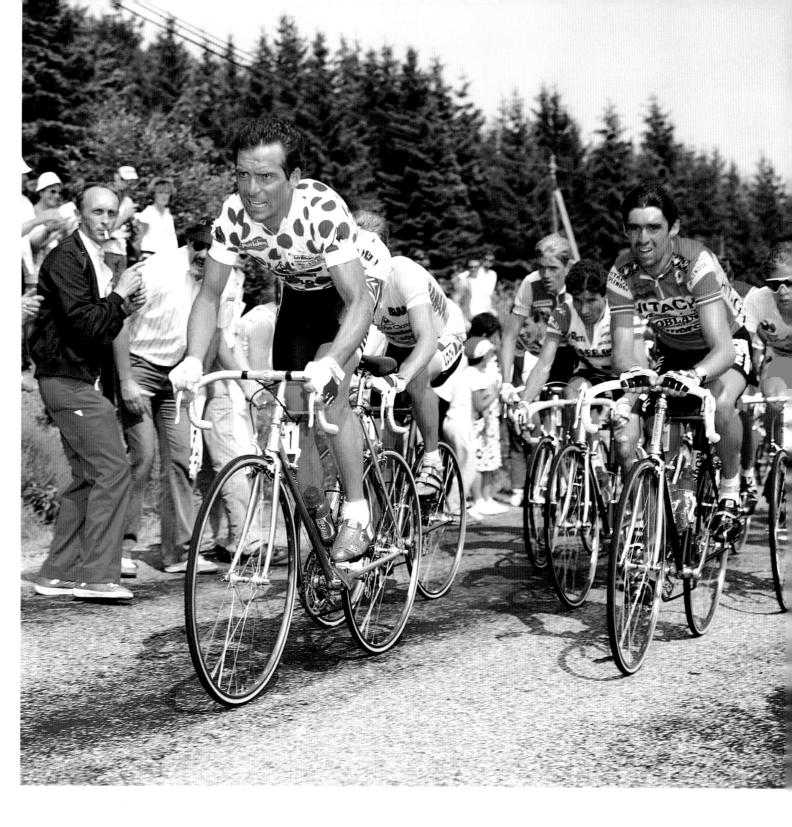

Left: **Tour de France, l'Alpe d'Huez, 1982**
Once again Hinault rides at the front of a group
chasing Beat Breu, the Swiss rider who held on to
win the stage. Hinault is leading two Dutch riders,
Johan van de Velde and Peter Winnen, who won on
this climb the previous year, and the Spaniard
Alberto Fernandez. The thing I find so surprising
about this picture is that if I took it today I would
probably get run over by a TV motorbike. I would
also be struggling to hold my place in a huge crowd
of fans at the side of the road, so big has the Tour
grown.

Right: **Bernard Hinault, Tour de France,
col de la Croix-de-Chabouret, 1986** As
ever Hinault is at the front. His team mate Greg
Lemond may be the race leader with Urs
Zimmerman also heading for the podium, but
Hinault is not going to miss any opportunity to
impose his personality by riding forcefully. This was
his last Tour, and Hinault rode his last race, a
cyclo-cross, in February 1987.

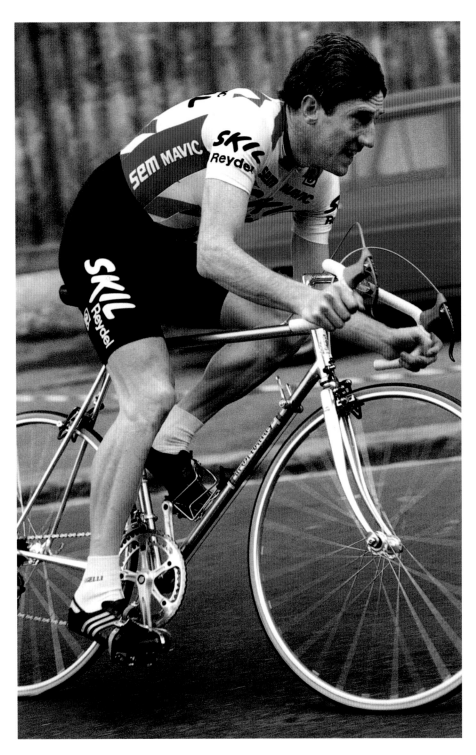

Left: **Sean Kelly, Paris–Nice prologue, 1984** Kelly shows the raw power that characterised his long and successful career. In the opening time trial of 'The Race to the Sun', the Irishman strains every sinew as he attempts to lay the foundations for another overall victory in the race that he made his own between the years 1982 and 1988.

Below: **Sean Kelly & Robert Millar, Tour de France, Luz-Ardiden, 1985** This was the stage that Bernard Hinault rode with two black eyes after his crash the previous day at St Étienne. It was also at this time that Kelly, who had finished fifth overall in 1984, was being touted as a podium contender. For a sprinter he could climb well. The rider alongside him, Robert Millar, had by this stage in his career already won two mountain stages and a polka dot jersey. Kelly finished fourth overall in this Tour which was to be his best ever performance. His only day in the yellow jersey during the 1983 Tour was the closest he would come to the ultimate prize. This stage was won by a young Pedro Delgado who would go on to win the overall just three years later.

Right: **Sean Kelly, World professional road race championship, Austria, 1987** Kelly tried to win the road race title so many times. At times he came agonisingly close. On this occasion he was the bridesmaid and not the bride as he had to sit back and watch his compatriot Stephen Roche crown an amazing year by nipping away in the final miles to win alone.

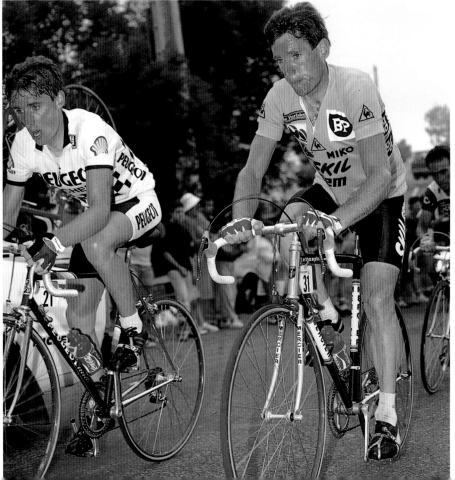

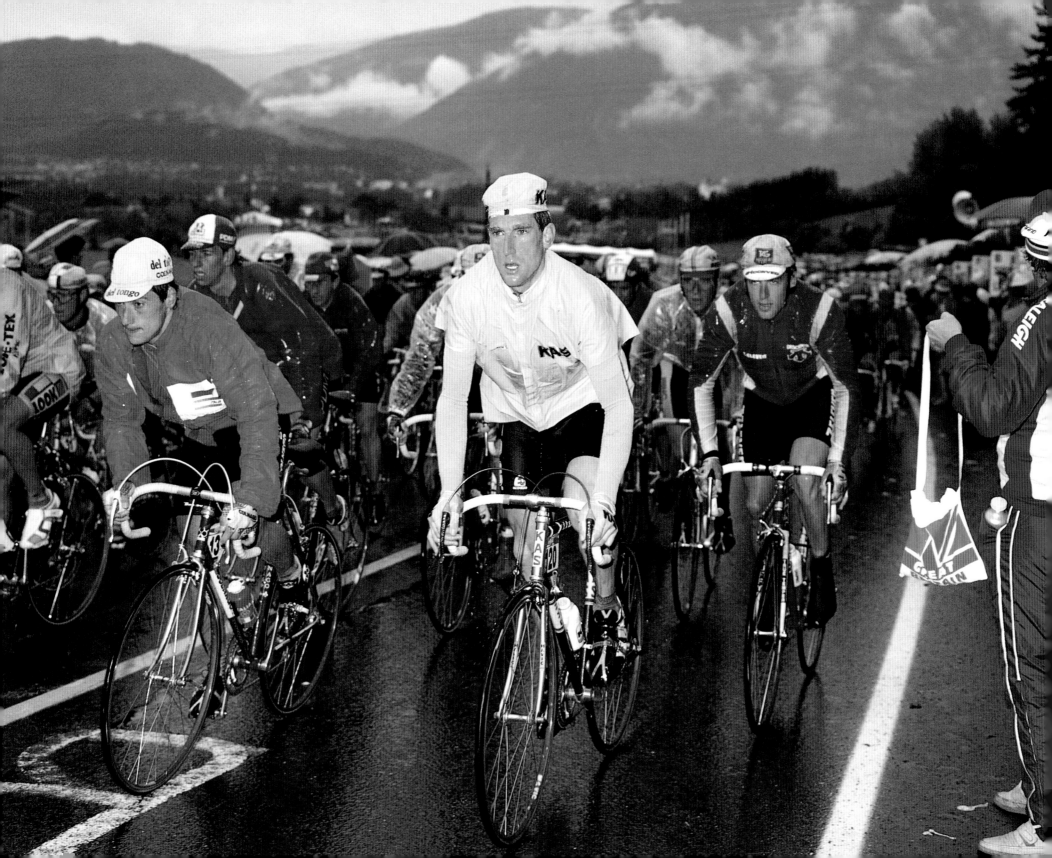

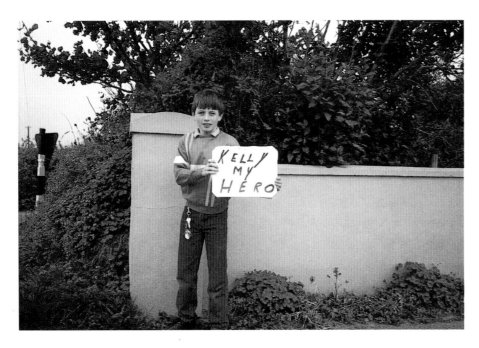

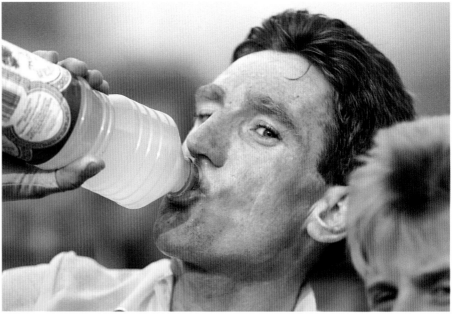

Above left: **Nissan Tour, Ireland, 1986** When a cyclist can inspire a nation's youth you know you must be talking about someone very special.

Above: **Sean Kelly, Nissan Tour of Ireland, 1987** A hot and sweaty race leader knocks back a drink at the finish of a tough day defending his jersey. It is unusual to see Kelly looking so stressed, a sign of the pressure he was under during his home Tour, when fans and media alike expected him to win.

Right: **Sean Kelly, Nissan Classic, Ireland** Of the eight Nissan Classics staged in Ireland, Kelly won four. Here he is seen in the mid-eighties approaching his home town of Carrick-on-Suir where he was to be greeted as it's favourite son.

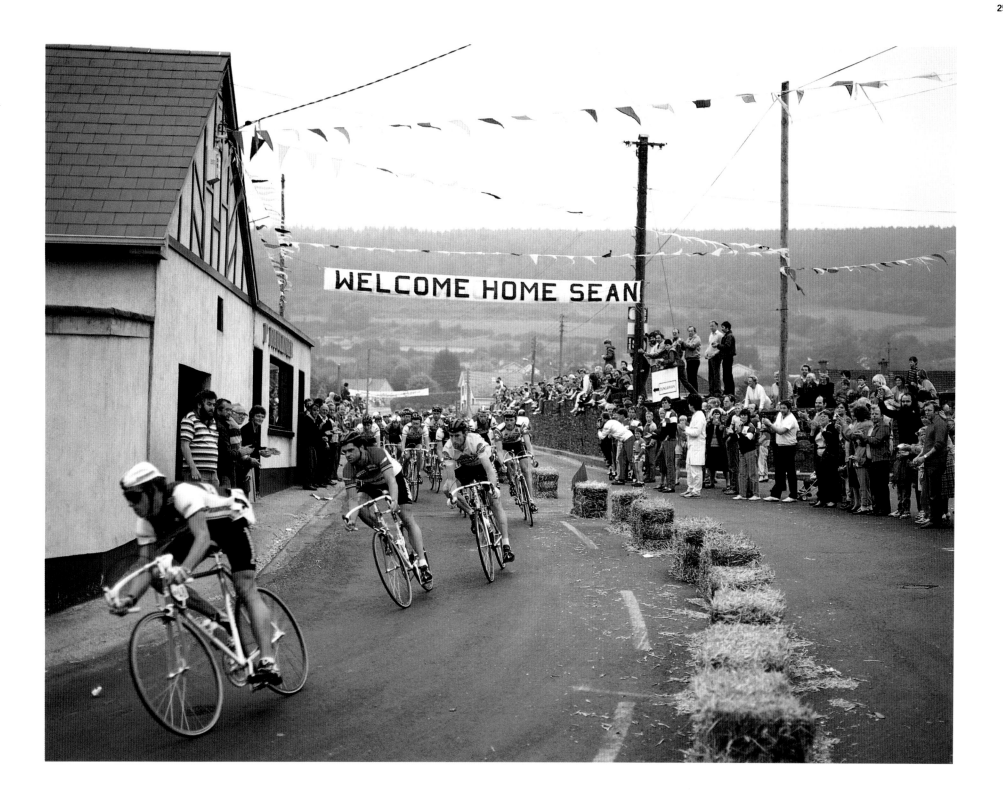

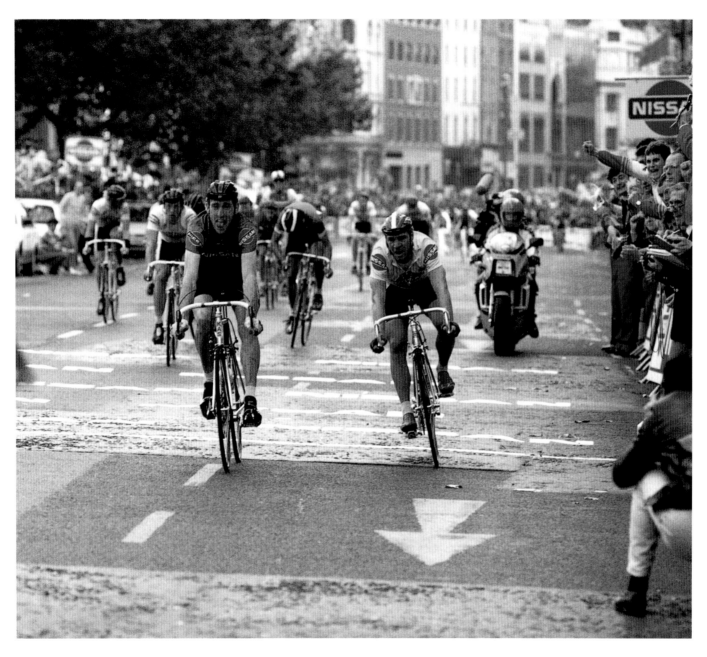

Left: **Nissan Tour of Ireland, 1986** This was real drama. Sean Kelly had to beat Steve Bauer in the final stage on O'Connel Street to take the time bonus that would give Sean the overall victory. If anyone thought that this was an arranged sprint to allow Kelly to win in front of his home crowd, one look at the faces of the two men sprinting it out tells the real story.

Right: **Sean Kelly, Carrick-on-Suir, Ireland, 1994** I went to see Kelly at home to get some pictures for a special edition of *Cycle Sport* magazine when he retired. Here, sitting on a wall by the river, he looks every inch the hard man that he is. I was feeling rather sore from running a marathon the day before and I asked Kelly how he felt the day after a race like Paris–Roubaix. He replied that you felt really bad if you finished second because it meant that you had gone very deep into your body, and you had given everything you had to win it. But if you won, it didn't hurt quite so much because you had only expended enough energy to win.

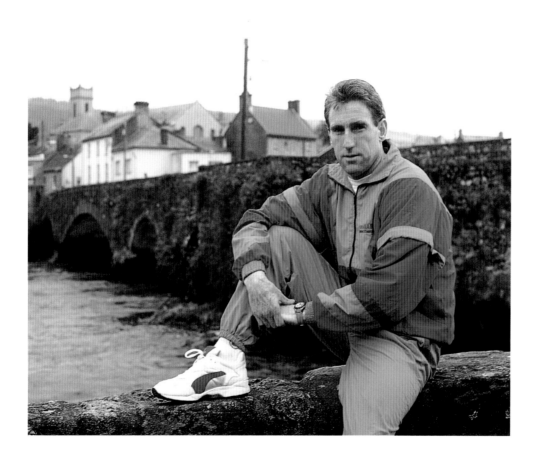

Left: **Robert Millar, Tour of Spain, 1985**
Here he receives the climber's jersey and retains the leader's jersey in the 1985 Vuelta after defending it in the Alcala de Henares time trial. The following day he and his Peugeot team were deceived when a combine of Spanish riders worked together to ensure that Pedro Delgado took the lead.

Right: **Robert Millar, Alcala de Henares, Tour of Spain, 1985** Incredibly Millar was leading the Tour of Spain with only a few days to go. I took a train all the way to Madrid to witness these incredible moments. In this photograph Millar is finishing the time trial with his large flange hubs, chrome toe clips and Cinelli bars and stem just like I had on my bike! The only difference was that he was holding on to the leader's jersey. Interestingly there was not a yellow skin suit for him to wear, so you will have to believe me when I say he was in the lead for this picture. He finished third on this stage and held onto the jersey with only a simple road stage the next day. The rest, as they say, is history.

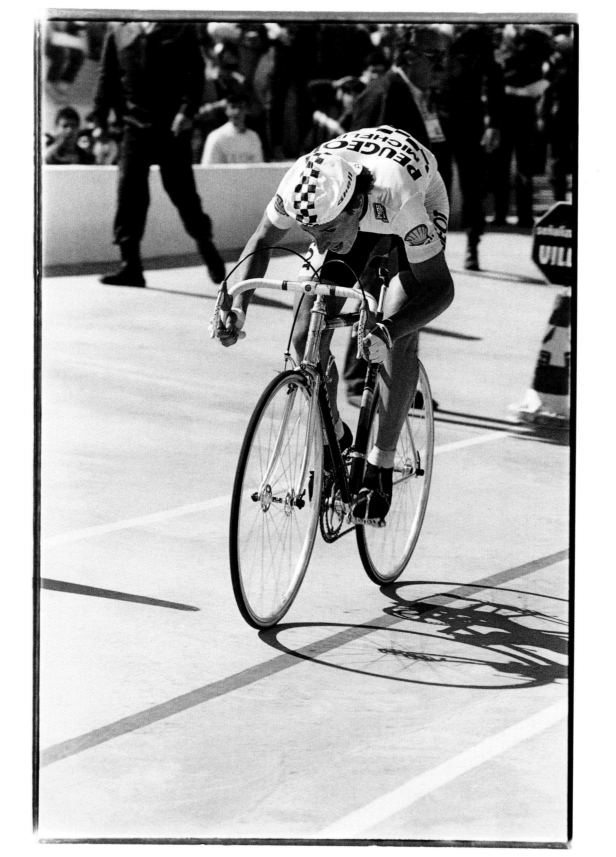

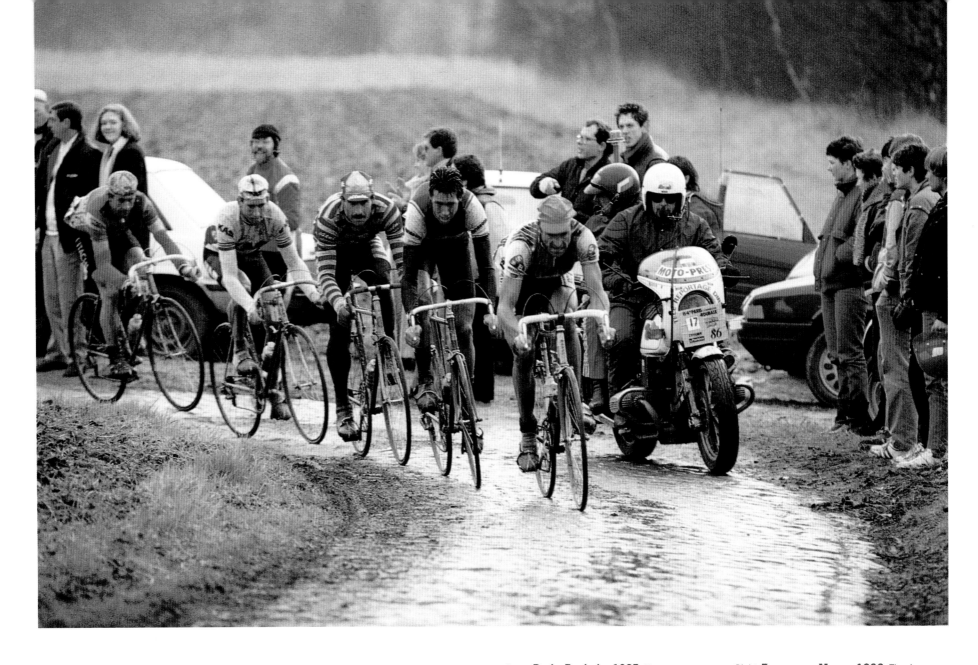

Above: **Paris–Roubaix, 1985** Francesco Moser leads Johan van de Velde, Urs Freuler and Sean Kelly who was to triumph this time. Was this the moment when Moser, the three times winner of this Queen of Classics and eighth place finisher this time, passed on the mantle to Kelly, who was to win twice?

Right: **Francesco Moser, 1986** The day Moser came to Leicester track in England is no doubt still remembered by all those that spectated. He just looked so cool!

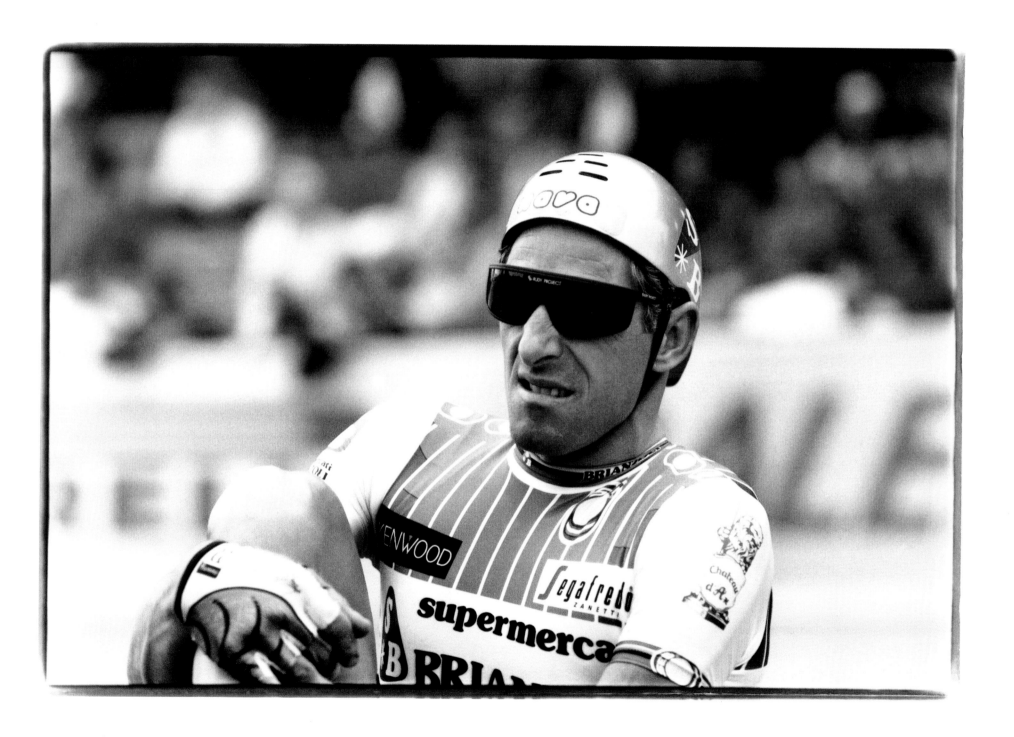

Left: **Francesco Moser, Trentino, 1992**
Reporter William Fotheringham and I went to
Trentino to meet Francesco Moser to do a feature
for *Cycle Sport* magazine. I don't speak Italian, so I
didn't understand a word he said, but I still came
away aware that I had spent a day in the presence
of a superstar who exuded style and charisma.
When you consider this alongside his career record,
it's easy to see why the fans loved him. Even
though his racing days were over when we visited, it
was clear that people still held him in the highest
regard. As we walked through his town, people
approached him to shake his hand, without any fuss
or bother, just simply as a way of showing their
respect to one of Italy's campionissimos.

Right: **Francesco Moser, Grenoble 6-day,
1982** Francesco, a former world hour record
holder, won 14 six-day races during his career.

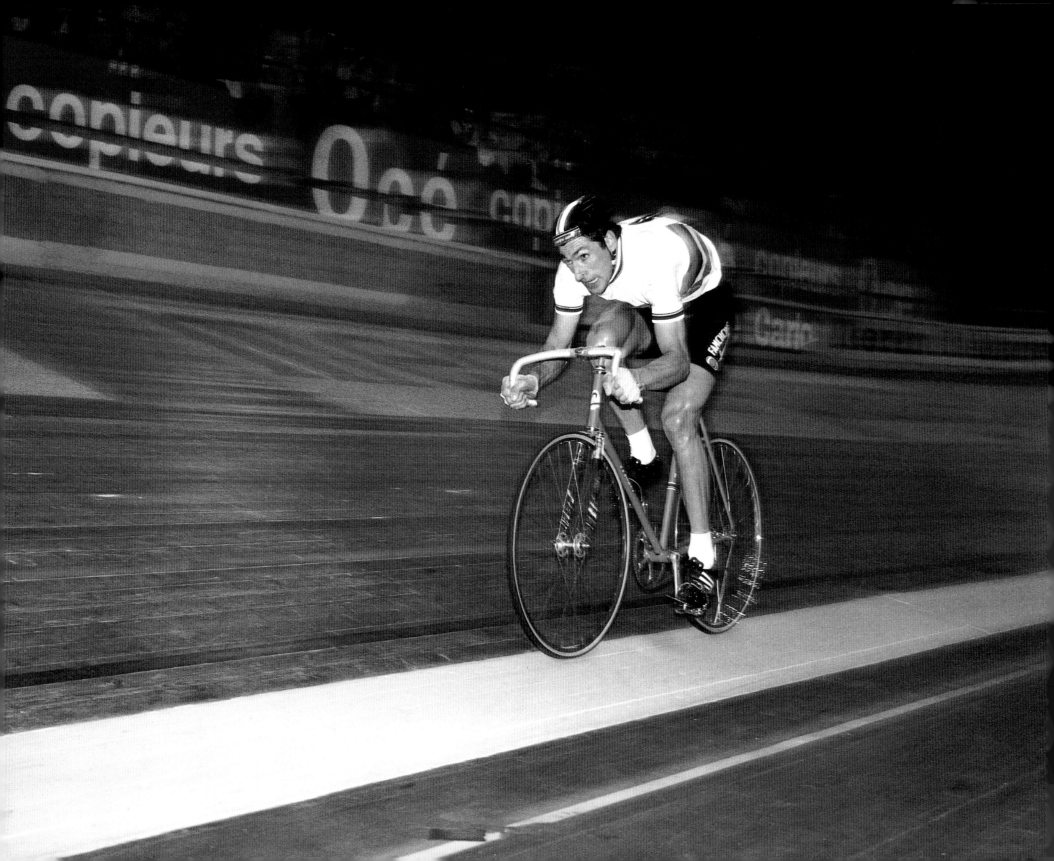

Below: **Claudio Chiappucci, Italy, 1993**
This was one of those 'you have got five minutes to get a picture' situations, which is often the case when dealing with people with busy schedules. In 1993 Chiappucci was a superstar in Italy, a position he has held since he became the surprise leader of the Tour de France in 1990. On other occasions when I photographed him, time was not an issue, but on this day he had been delayed because of a TV interview and was about to leave for a medical in Milan. We ended up grabbing this picture then getting in our hire car, which he insisted on driving, and continued the interview in the car. We carried on talking to him and taking photos in the doctor's waiting room before we had to leave to catch our plane home. I barely understood a word he said but he was great fun to be with.

Right: **Claudio Chiappucci, Tour de Romandie, 1995** As a one-time sports agency photographer this is exactly the type of photo you are asked to come up with at every opportunity. Get in tight and have a perfect background. Although Chiappucci was only warming up for the time trial, it can't have been that bad as it must be the only warm up picture that has ever made the front cover of *Cycling Weekly.*

Far right: **Claudio Chiappucci, Tour de Romandie, 1995** As a photographer it is a dream to be able to go to a race that has all the stars, the most dramatic scenery, good weather and almost no crowds. Not only does it give you the chance to get the pictures you want, but also you don't get stuck in an endless traffic jam for hours afterwards. Here Chiappucci leads Laurent Dufaux on a stage of the ever scenic Tour de Romandie, a race that fits the bill for me. The Tour de France may be the biggest race of the year but it is also the biggest headache for those who work on it.

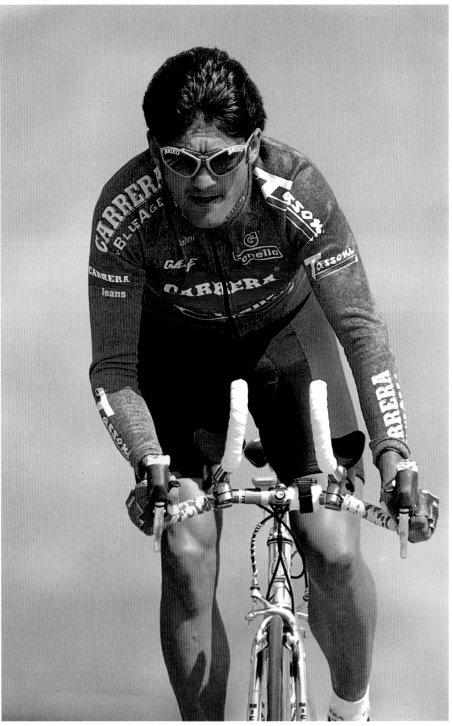

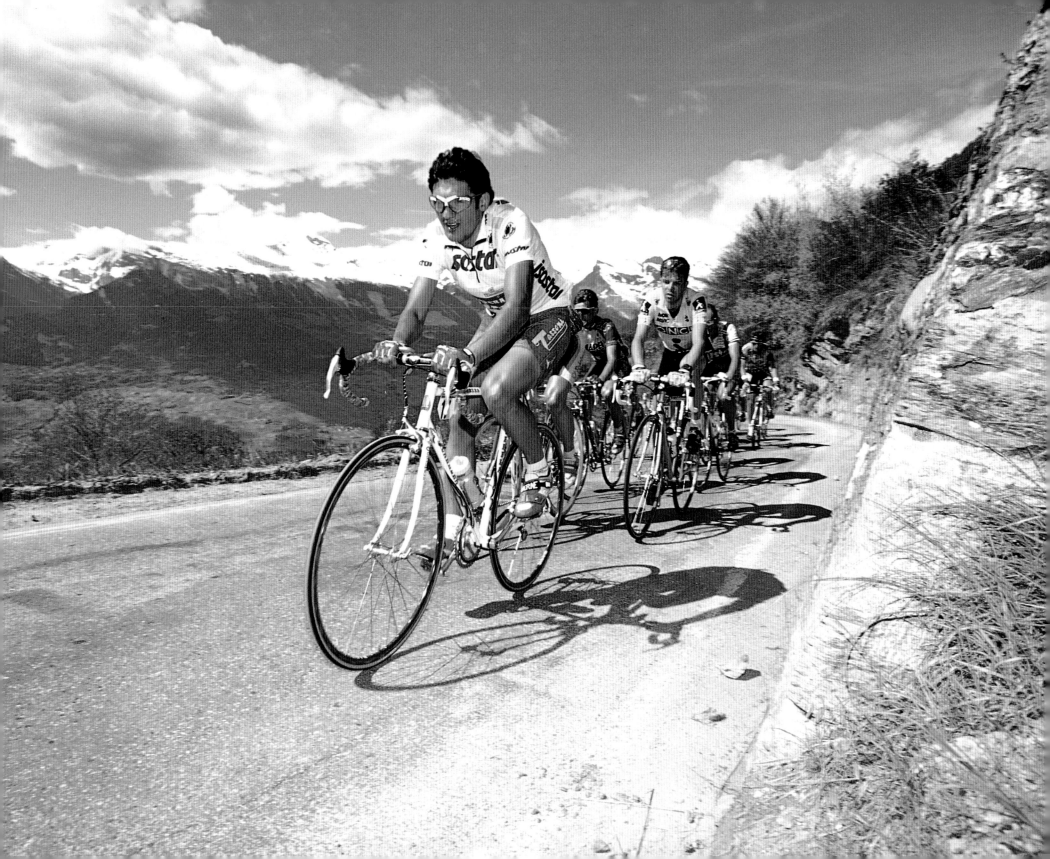

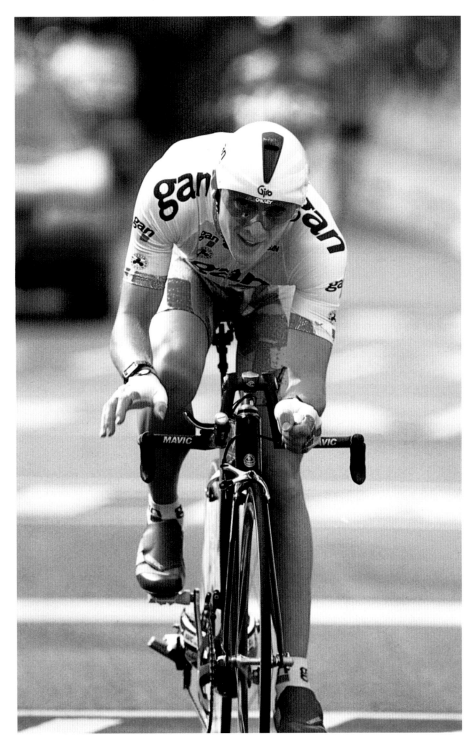

Left: **Chris Boardman, Tour de France prologue, 1994** In the week leading up to Chris's debut I had been in touch with him and other people in his camp. Knowing him, as I did, if he was preparing for this one stage alone then I felt a win was on the cards. I told a journalist at *Cycling Weekly* that Chris was going to win and he looked at me incredulously. A veteran of many races he could not fathom it, "Have you seen the size of these guys? I mean this is the Tour de France, he's not going to beat Miguel Induráin and Alex Zulle, they have come here to win this race." For a second I thought he might be right.

Come the event I ignored the other riders and stayed within photographic distance of Chris all day. He was completely focused. Later I learnt that in the days before the event he had been riding through all the corners as fast as he could to see if it was possible to take them without braking. His manager was driving behind him and was amazed at his rider's dedication. I took a number of pics of Chris on the start ramp and an action shot, and then ran through the streets of Lille to get to the finish before he did. I looked up at the clock to see the time he had to do. I then noticed Phil Liggett commentating for Channel 4 and realised by the look on his face that this was something really special.

One or two riders came into view and then Chris appeared. I could see straight away that he was going to be fastest. The picture caught him the moment he crossed the line with the semblance of a smile on his face. Perhaps he is relieved that the pain of a job well done is over and the realisation that maybe he was going to win. Over the next few minutes the heavyweights of world cycling came and went, and each time I held my breath as they failed to beat his time. Finally Miguel Induráin came into view and amazingly it was apparent that not only had Chris beaten him but thrashed him by an incredible 15 seconds. It was astonishing.

Minutes later Chris was up on the stage and Bernard Hinault was telling him to step onto the podium to receive the yellow jersey rather than stand politely next to him. You are the champion young man, enjoy it! On my drive home that night my phone rang in the car and it was the journalist who had earlier questioned my prognosis for this event. He was more than happy to say that I was right, it was quite literally an amazing story.

Right: **Chris Boardman, Hour record, Manchester, 1996** This was a seminal year for Chris. He came back from his crash in the Tour de France prologue at Saint-Brieuc (after which one wag said "well at least he was the first person to finish the Tour!"), rode superbly in the Paris–Nice and Criterium International, took a bronze at the Atlanta Olympics and then destroyed the world pursuit record at Manchester. The next step was to have a crack at the hour record that was a big building block in his career. The first time he broke the record the door to a professional career was opened. Now, 3 years later, he had superb form and a position on his bike was available to him that tests had shown was the best. This position was also about to be banned, so it seemed a shame to waste it! In front of a noisy home crowd he pulverised the record. He rode 4 kms further than his earlier effort in Bordeaux. To put it in context that is 16 laps further, or another way to describe it is to say that if both efforts had taken place simultaneously he would have lapped himself once every 4 minutes!

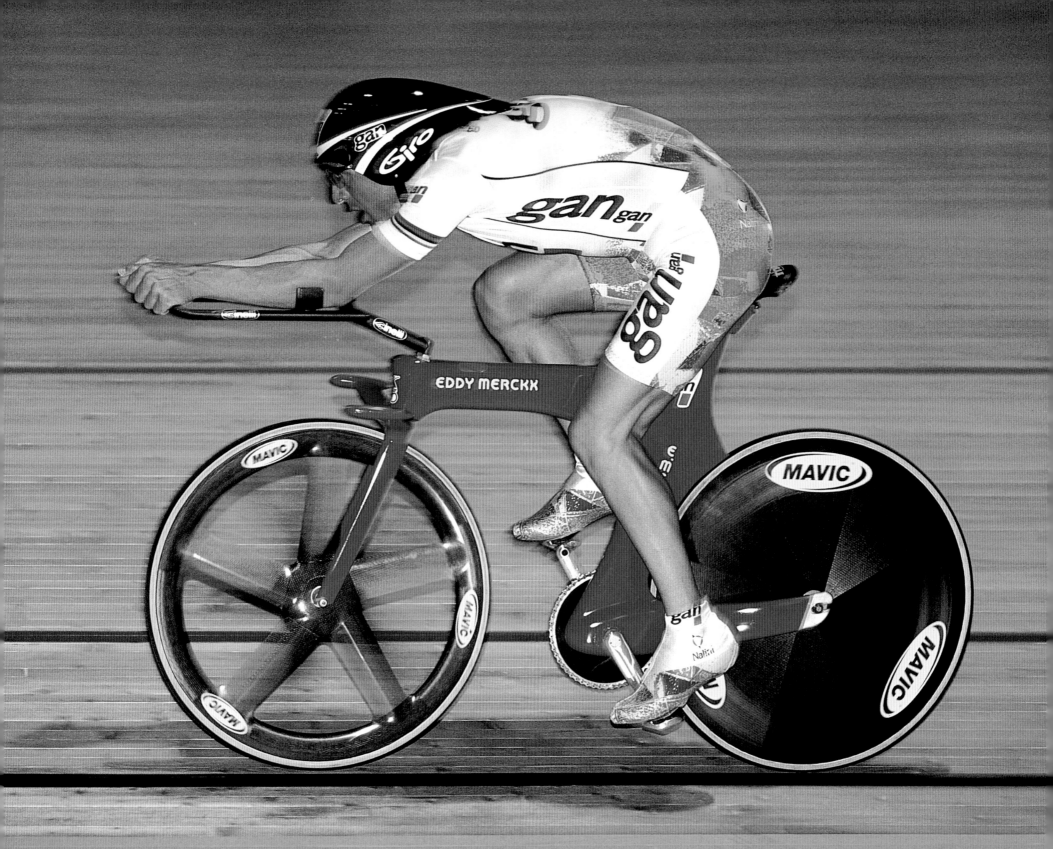

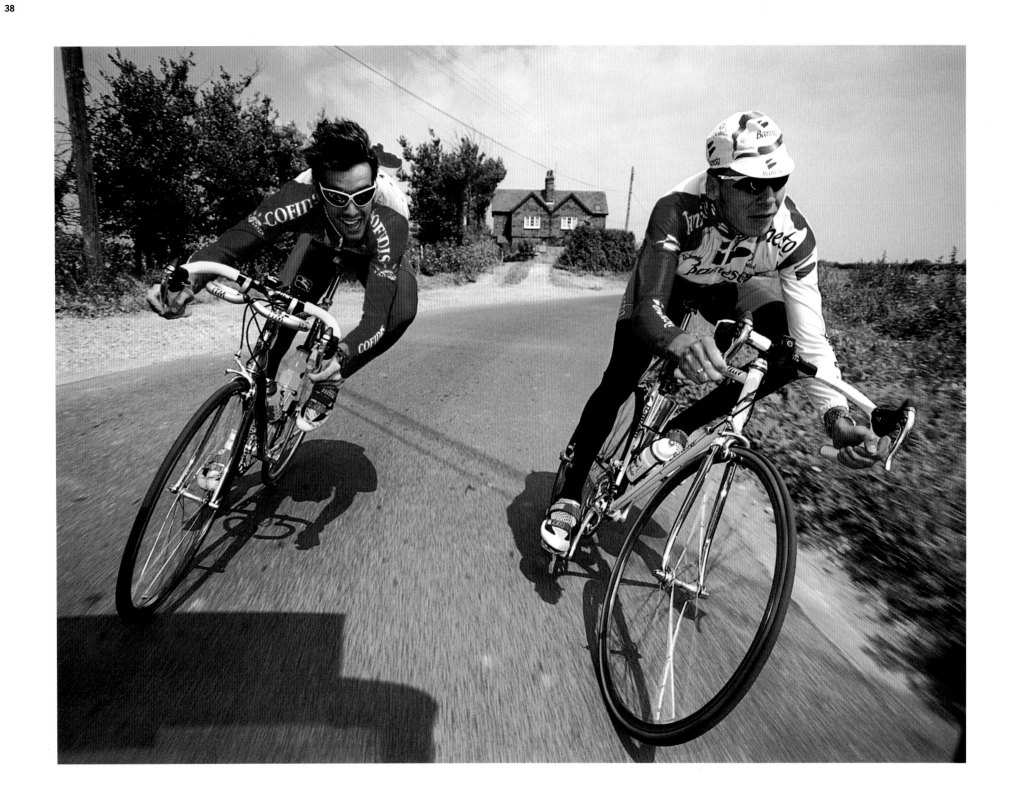

Left: **David Millar, Jeremy Hunt, Berkshire, 1997** I love this picture as it sums this talented pair up in one image: two friends who were young, carefree, and on occasion, wild. I had been taking various pictures from a moving car driven by reporter Kenny Pryde. They were okay but not great, and then Kenny suggested I get in the boot and take some shots from there. Perfect, it was the catalyst that was needed. The response from Dave and Jez was instant as they attempted to slipstream the car, and all the previous pictures were thrown in the bin.

Above: **Jeremy Hunt, Essex Grand Prix, 1992** This was Jeremy's first year as a senior and he was riding for SG Bollington. It is not often you get a picture of a rider in a pink jersey passing a pink painted house, so I grabbed the moment. SG

Bollington was a club set up by Mike Taylor, a man who has been mentor, coach and confidant to many riders over the years. Taylor, who was briefly the manager of the GB Junior team, has helped the careers of Paul Sherwen, David Millar and Charly Wegelius, and more recently, riders like the promising Steven Cummings.

Right: **David Millar, Merseyside invitation time trial, 1995** Dave won the fastest junior prize on the day when Chris Boardman made his comeback in the classic time trial through Delamere Forest, 100 days after crashing out of the Tour de France prologue. Dave finished in sixth place, three minutes and thirty-one seconds behind Boardman. Just under five years after this picture was taken, Dave won the Tour prologue himself.

Far left: **Jeremy Hunt, Tour of Majorca, 1996** Suddenly Britain had a bunch sprinter who could put himself in there with the best. This was Jeremy's first race as a professional and here on a stage to Cala Millor he narrowly missed out to Frederico Collona.

Left: **David Millar, Tour de France, 2000** Blimey! Dave is leading the Tour de France! There had certainly been some talk about whether he could win the 10-mile prologue of the 2000 Tour. Dave famously beat Lance Armstrong, who was out to teach everyone a lesson from day one. From where I was sitting to take the pictures you could feel the wind getting stronger and by the time Dave whizzed by it was very hard. On the exposed course it was going to take an amazing effort to beat those who had had the earlier better conditions, and the fact that the young Brit did just that, made the ride all the more incredible. Standing on the winner's podium he looks quite overawed!

Left: **Sean Yates, Kellogg's Criterium, Bristol, 1984** Sean did not win a lot of races but on this particularly tight circuit he succeeded in holding off Stephen Roche and Malcolm Elliott to take the victory.

Right: **Sean Yates, Herne Hill, 1983** Sean returned to Herne Hill as a Peugeot professional to relive his days with the 34 Nomads club and to engage in a one-off pursuit against Dave Lloyd. The self styled 'Cock of the north', Lloyd had been having an incredible season and when he arrived at the south London track meeting he seemed to be everywhere. His confidence knew no bounds, whereas Yates was nowhere to be seen. In fact he was quietly warming up on rollers away from the crowds, and when the event was called he appeared at his station as if from nowhere. The photo shows him being pushed off by his dad Roger. A few minutes later Yates caught Lloyd and if the 'Cock of the north' had had a tail then it definitely would have been between his legs.

Overleaf left: **Sean Yates, Tour DuPont, USA, 1995** Sean will always be remembered for his selfless dedication to the teams he rode for during a long pro career. When he took the yellow jersey in the 1994 Tour de France, the whole peloton was pleased for him. The Maillot Jaune was a reward for all the times he has worked for team leaders just as he is doing in this picture where he is keeping the pace high to protect Lance Armstrong's lead on a wet day to Asheville, North Carolina.

Overleaf right: **Sean Yates, Tour de France, St Étienne time trial, 1986** At this stage in Sean's career he was still very muscular, the effect of hundreds of press-ups every morning had left him with a physique that needed trimming down.

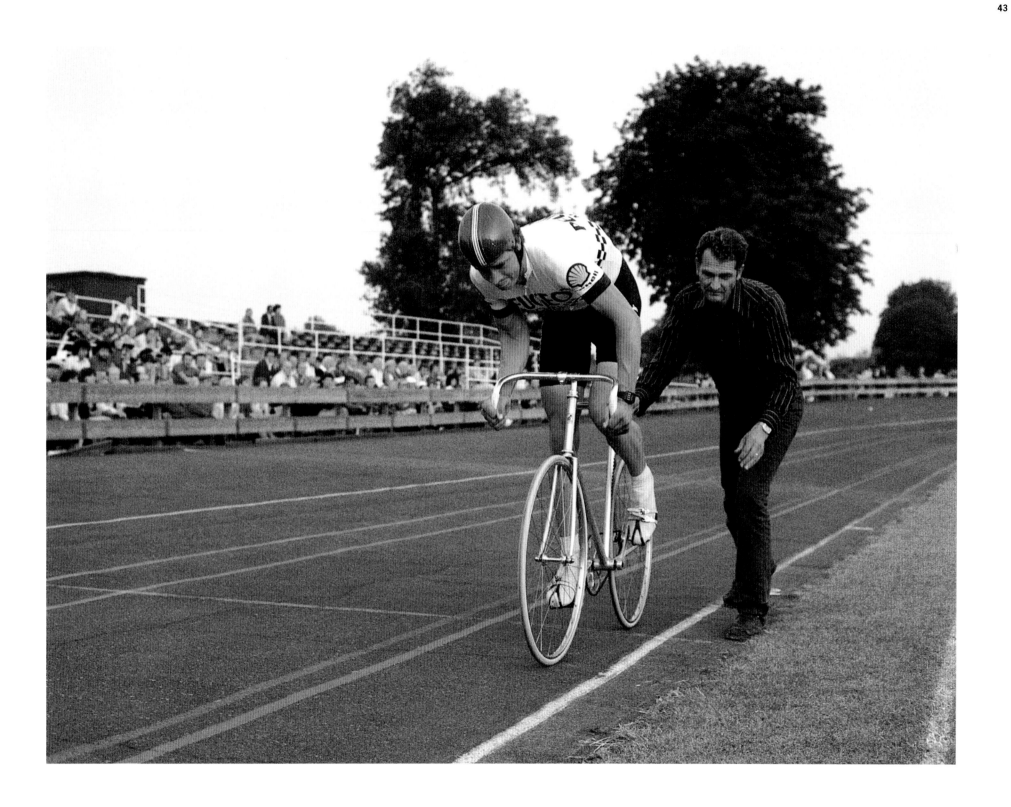

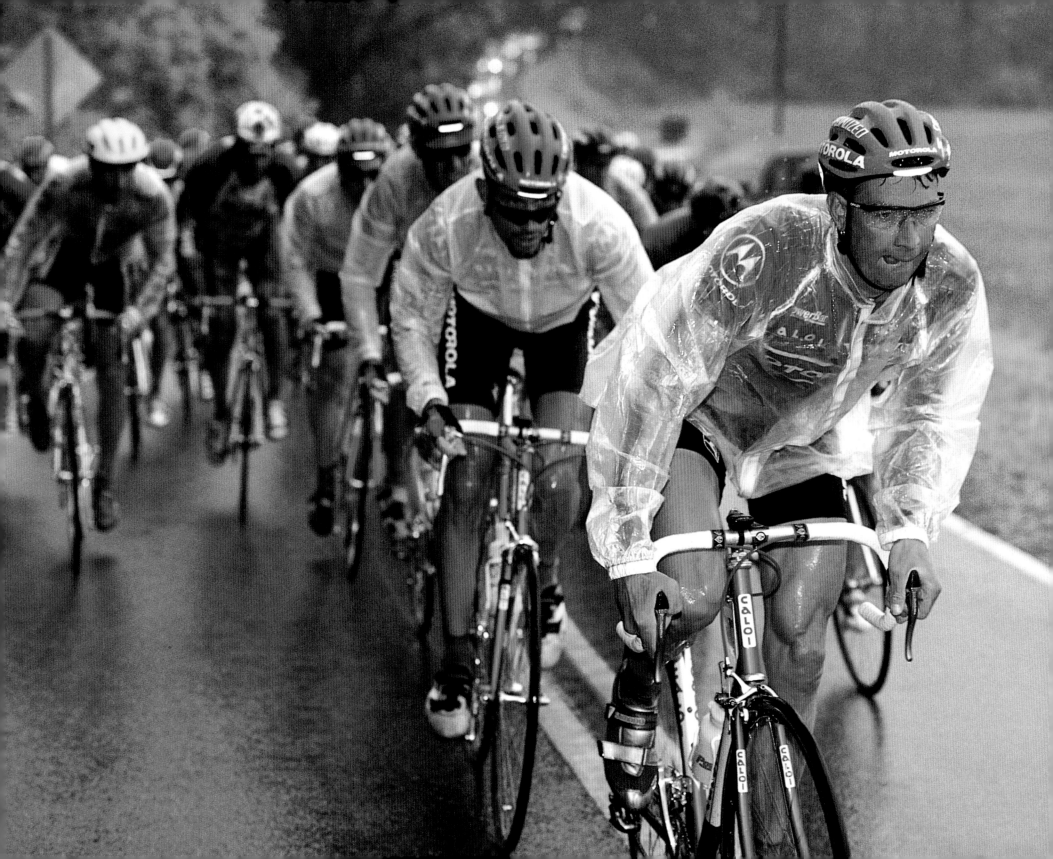

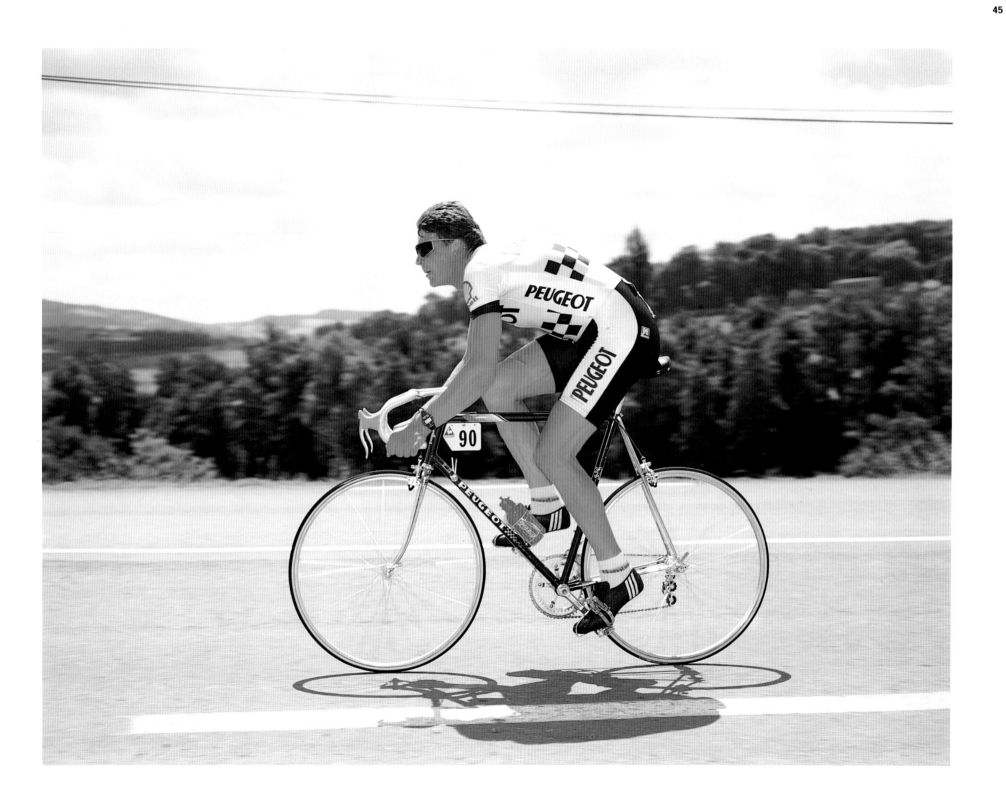

Below: **Graeme Obree, World hour record, Hamar, Norway, 1993** Not many people turned up to witness this piece of cycling history. The previous day Graeme, using his unique riding position, had failed in his bid to take Francesco Moser's record. Almost immediately he said he would go again the following morning and this time he made no mistake. A Scottish amateur, who had been considered by many to be a talented but eccentric time triallist, had broken cycling's blue riband record in an almost empty stadium. For those who were there, it was the most stunning hour of their lives, one that will never be forgotten. The fact that so few people witnessed it – and I was the only photographer who remained for the second attempt – meant that when I got home I was bursting with the euphoria of the occasion. I felt an incredible need to tell anyone who would listen what they had missed. At the same time, Chris Boardman was preparing for his attempt on Moser's record at Bordeaux so the rivalry, which already existed between the pair, intensified.

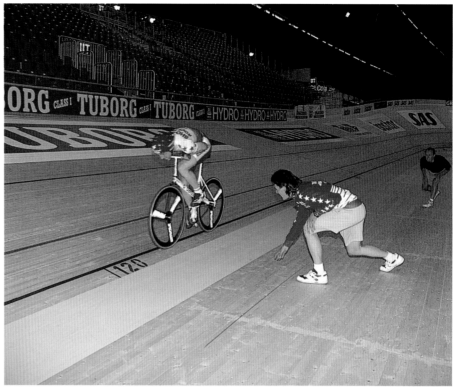

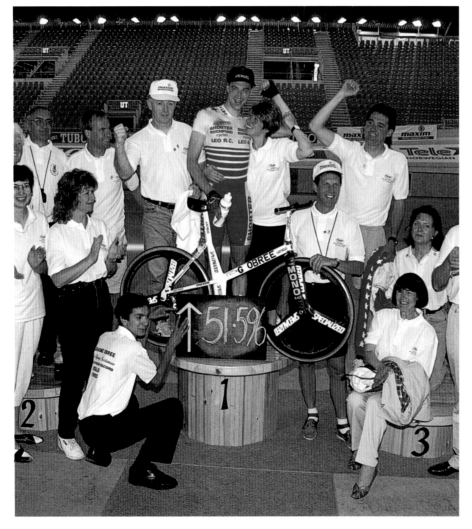

Above: **Graeme Obree, World hour record, Hamar, Norway, 1993** Only a few laps to go and he is cheered on by Alan Rochford as he was about to break the hour record that had been set by the legendary Francesco Moser in 1984. Obree shook the sport to its foundations with his attitude and riding position. Ultimately others copied the position, before the UCI banned it. He challenged years of tradition and thinking. When the UCI told him he could no longer use this riding position, he simply went away to plan his next move. In 1995 he won the world pursuit championship with his 'Superman' position. Once again the UCI were not impressed and they eventually also banned that.

Right: **Graeme Obree, British national 25-mile time trial championship, 1992** Obree by now was starting to make his name known outside Scotland, and he finished on the podium in this race alongside Chris Boardman. A close look at the bike reveals that it paved the way for the future hour record machine.

Far right: **Graeme Obree, Manchester** It is very rare that I set up a picture but this was the only way to get this one. The position had been nicknamed 'The Superman', so I needed a shot with Obree apparently flying through the sky. It turned out better than I hoped, which made up for lying in the road outside the Velodrome in an undignified manner while I got the picture. Interestingly, this image sold well to the non-cycling media but was only used once in traditional cycling magazines.

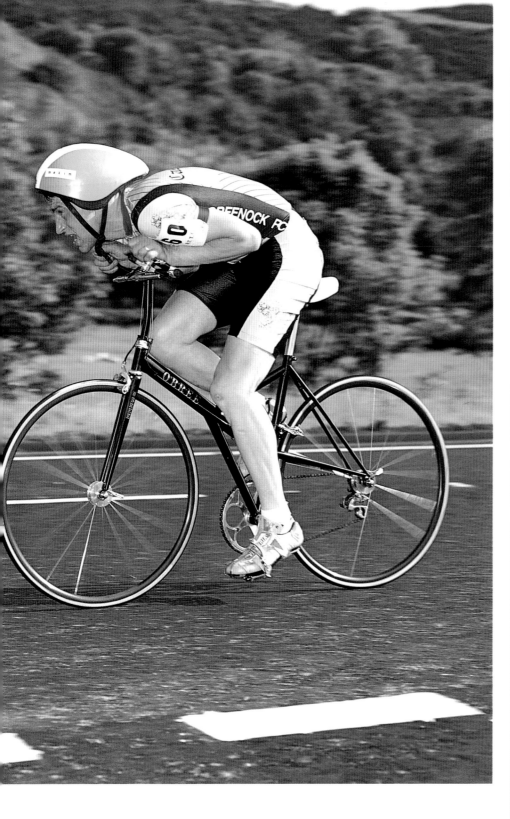

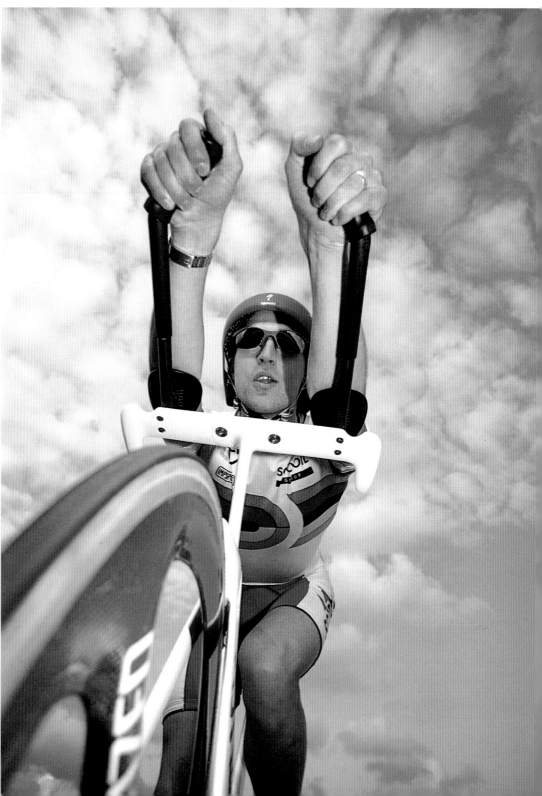

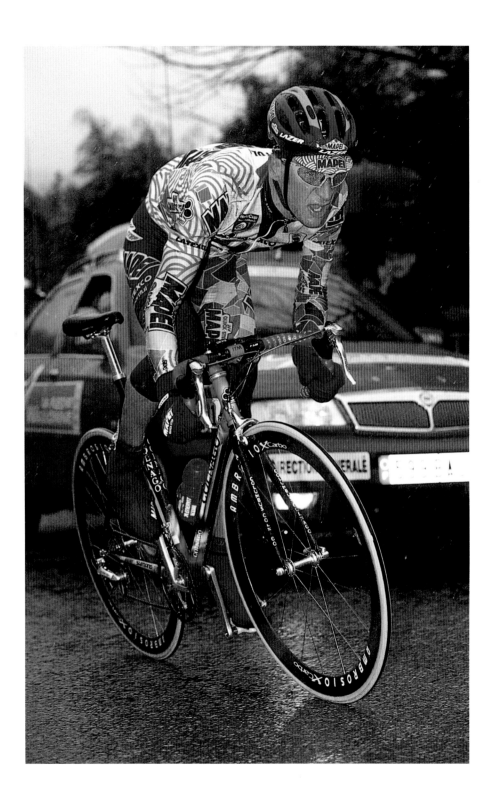

Left: **Michele Bartoli, Flêche Wallonne, 1999** The Italian ace is seen here riding through the sleet and snow to win what was an arduous Flêche Wallonne. This late April event, along with Liege–Bastogne–Liege, is often held in cold wintry conditions.

Right: **Laurent Jalabert, Le Dauphiné-Libéré, 1996** Jalabert had taken the leader's jersey after he and Richard Virenque attacked Miguel Induráin on Mont Ventoux. The following day Jalabert lost a little of his lead in the time trial which he rode on a machine that would now be illegal. France went mad as the nation's two favourites put the big man from Navarre under pressure, but the Spaniard just held his breath for a few days before giving everyone a master class in racing with a devastating performance on the Col d'Izoard.

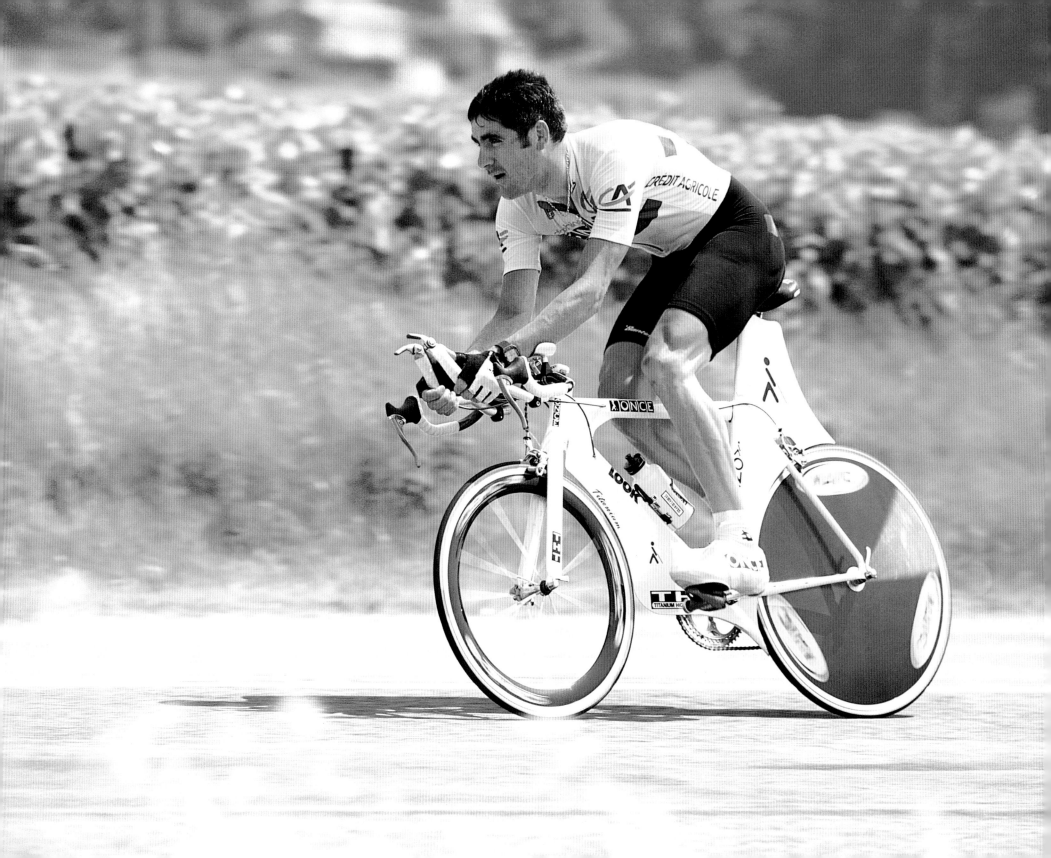

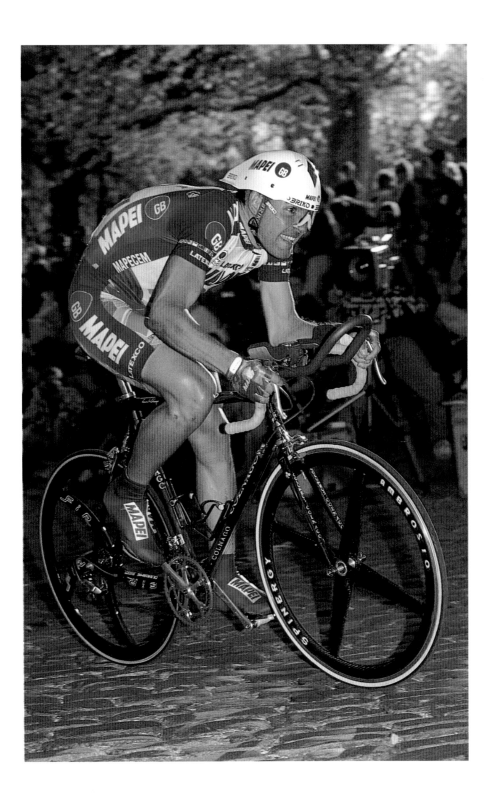

Left: **Gianluca Bortolami, Tour duPont, 1995** This was taken on Monkey Hill in Wilmington, Pennsylvania during the prologue time trial. The evening light is lovely as it rests on the cobbles of this steep hill.

Right: **Andy Hampsten, Tour de Romandie, 1994** This to me is as good a portrait of Andy Hampsten as I could hope to get. The 1988 Giro d'Italia winner is a real mountain goat, and here he is on a particularly stunning day riding in an environment in which he is most comfortable. Hampsten was one of the first riders to ditch the left hand STI rear gear changer in favour of the lighter, down tube lever. It may not look right to the aesthetic purists, but in the mountains every weight saving measure counts.

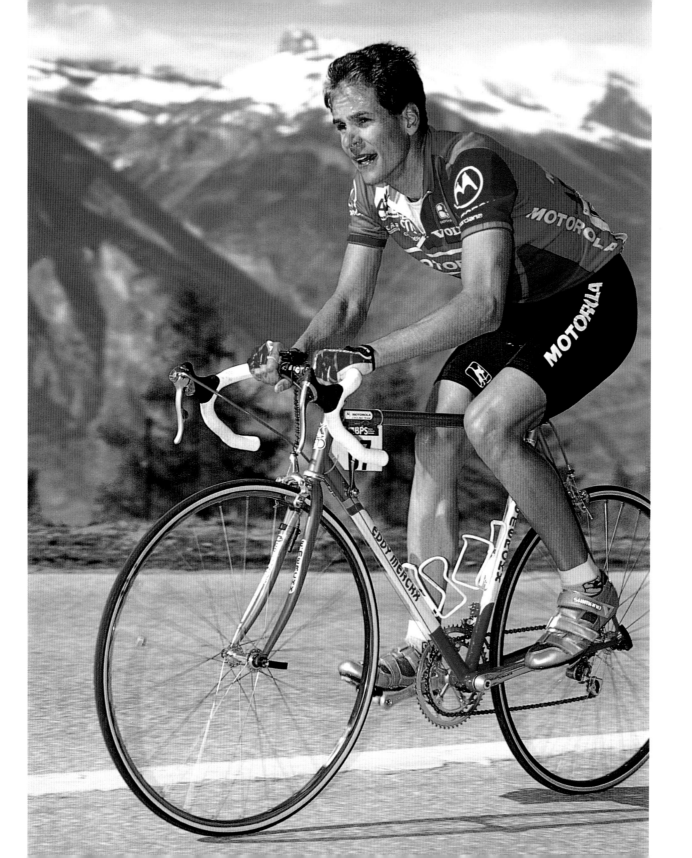

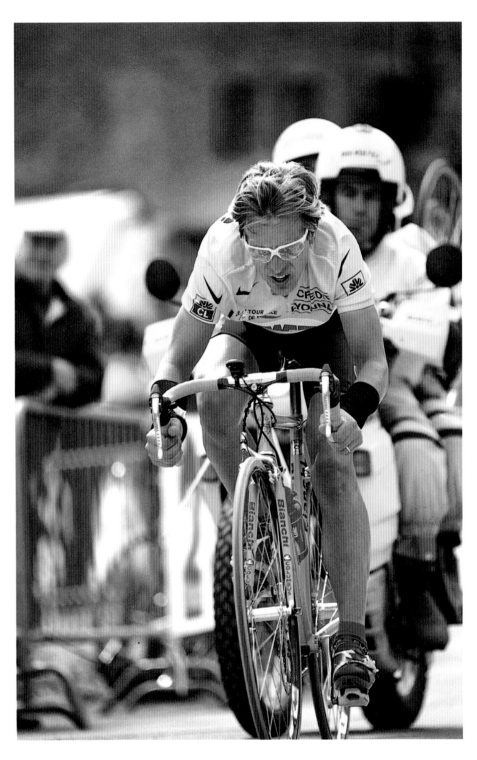

Left: **Evgeni Berzin, Tour de France, Sestrierre, 1996** This shows the Russian under strain as he rides as hard as he can to the finish in Sestriere in the knowledge that he has probably lost the yellow jersey to Bjarne Riis. Indeed he had, and he was to never again wear the leader's jersey of the Tour de France.

Below: **Michael Boogerd, World road race championship, Holland, 1998** Held in filthy conditions, this was a great race that turned into a trial of strength. As the race headed for its final hour it was down to a small group of hard riders that included Michele Bartoli, Peter van Petegem, local hero Boogerd and a Swiss rider called Oscar Camenzind. When the Swiss rider jumped away in the final miles, those behind hesitated for too long and he escaped to finish alone.

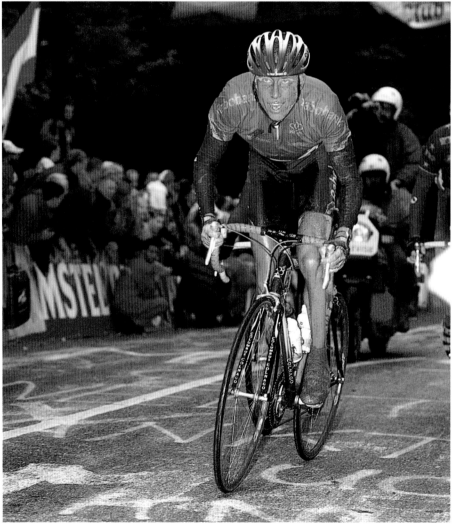

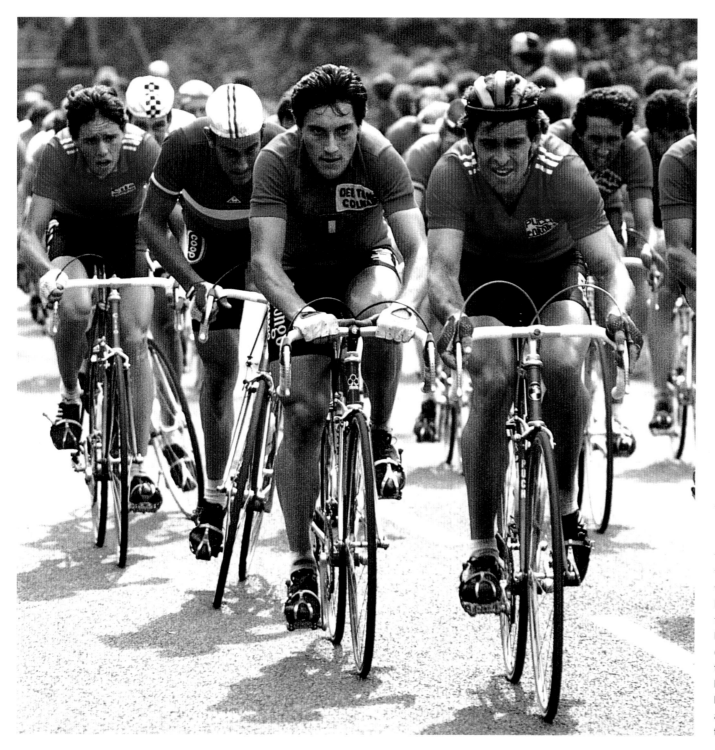

Guiseppe Saronni, World road race championship, Goodwood, 1982 Heading for victory on British soil. At the time of this win Italian cycling fans were divided between Saronni and Francesco Moser. Years after this picture was taken, I was having a meal with some Italians when the conversation turned to who was the best. All were Moser fans except one, and the debate got louder and more passionate, until the lone Saronni fan produced a cardboard tube in which he had a large poster of his hero wearing the world championís jersey. He unrolled it and placed it on the floor and then proceeded to give his hero a big kiss. I was thoroughly entertained by this show of loyalty, even though someone later told me that this argument took place every night and usually ended the same way.

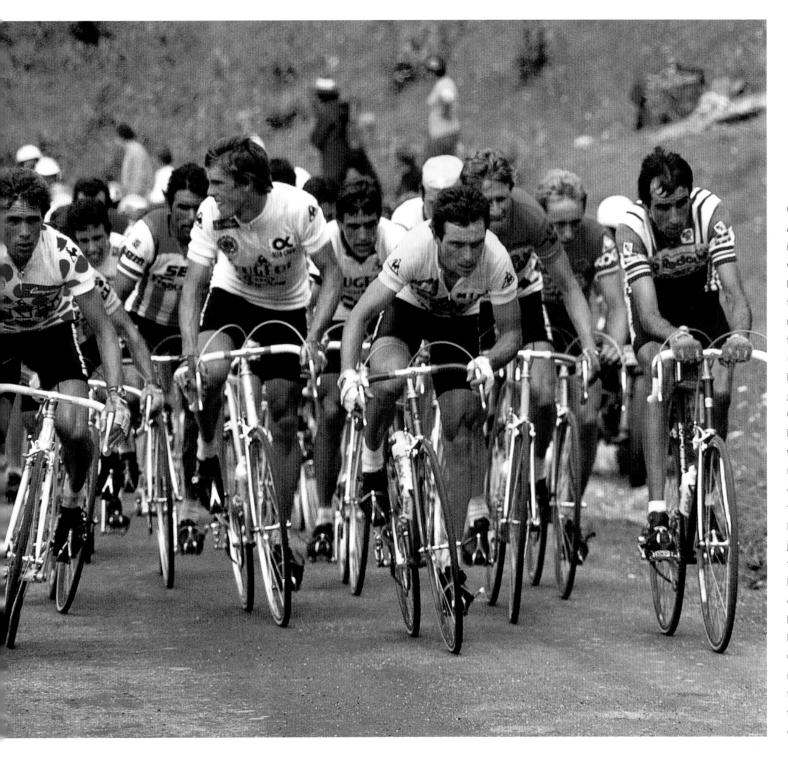

Col de la Ramaz, Tour de France, 1981
Another of my personal milestones. In 1981,
inspired by a weekend in Paris the previous year to
watch the finish of the Tour on the Champs Elysées,
I went back with a friend to watch it for real. Until
then, the Tour in the high mountains only existed in
my imagination as all I had to go on were pictures
from the French cycling media and reports in
Cycling Weekly. An Alpine climb was like nothing I
had ever experienced in the Surrey hills, so I have
good reason to remember that morning's ride from
Geneva Youth Hostel. Let's just say it took us a
long time. Eventually we reached the top and
waited for the Tour to arrive. Bernard Hinault did
not disappoint. He was riding at the front of a group
daring anyone to challenge him – a classic Hinault
tactic. Others in the picture are 1976 Tour winner
Lucien Van Impe and Phil Anderson in the white
jersey of best young rider who was doing his best
to challenge Hinault and refusing to be intimidated
by the Breton. Behind Hinault is Joaquim Agostinho
of Portugal. Wearing the yellow cap is Michel
Laurent of Peugeot who went on to become
Director Sportive for Chris Boardman's Gan and
Crèdit Agricole teams. The tall gangly rider on the
right is Robert Alban of France. It was all over in a
flash and we were left both with an empty road and
this image. Now I can recall that 500th of a second
of personal history whenever I want to!

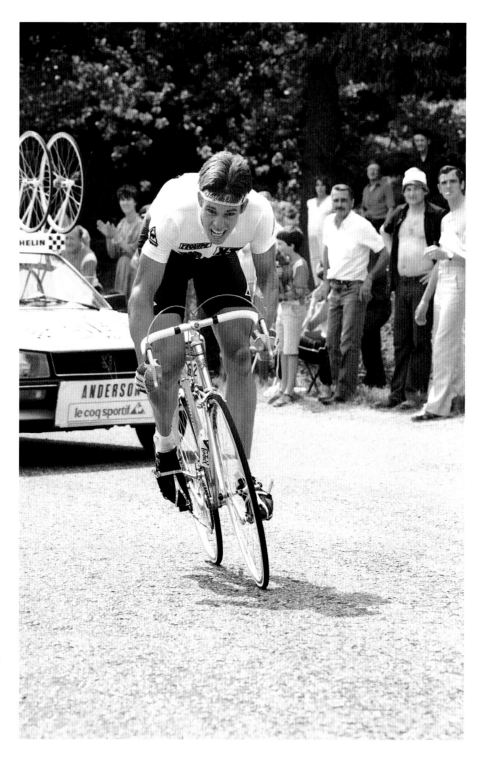

Phil Anderson, Tour de France, Saint-Priest time trial, 1982 If Anderson had come up against anybody other than Bernard Hinault he may have had a sniff at winning the Tour. The tough Aussie, however, finished this tour in fifth place overall.

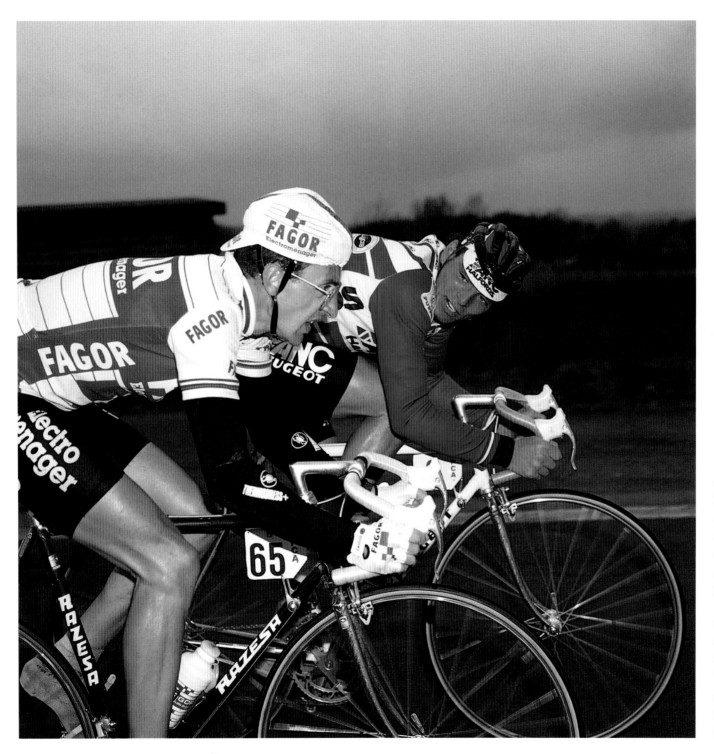

Left: **Martin Earley & Joey McLoughlin, Eastbourne–London, 1987** Just what was Joey saying? This was taken in the closing miles on a cold, wet day as they chased Shane Sutton who was to win from Paul Watson. It is yet another example of a classic race on British roads which no longer exists.

Right: **Joey McLoughlin, Paris–Nice, 1987** A photograph of Joey would always be good. This race was ridden as part of the ANC build up for the Tour de France. 1987 was a difficult year for Joey and he didn't make the Tour team, although he did bounce back to win the inaugural Kellogg's Tour of Britain in August.

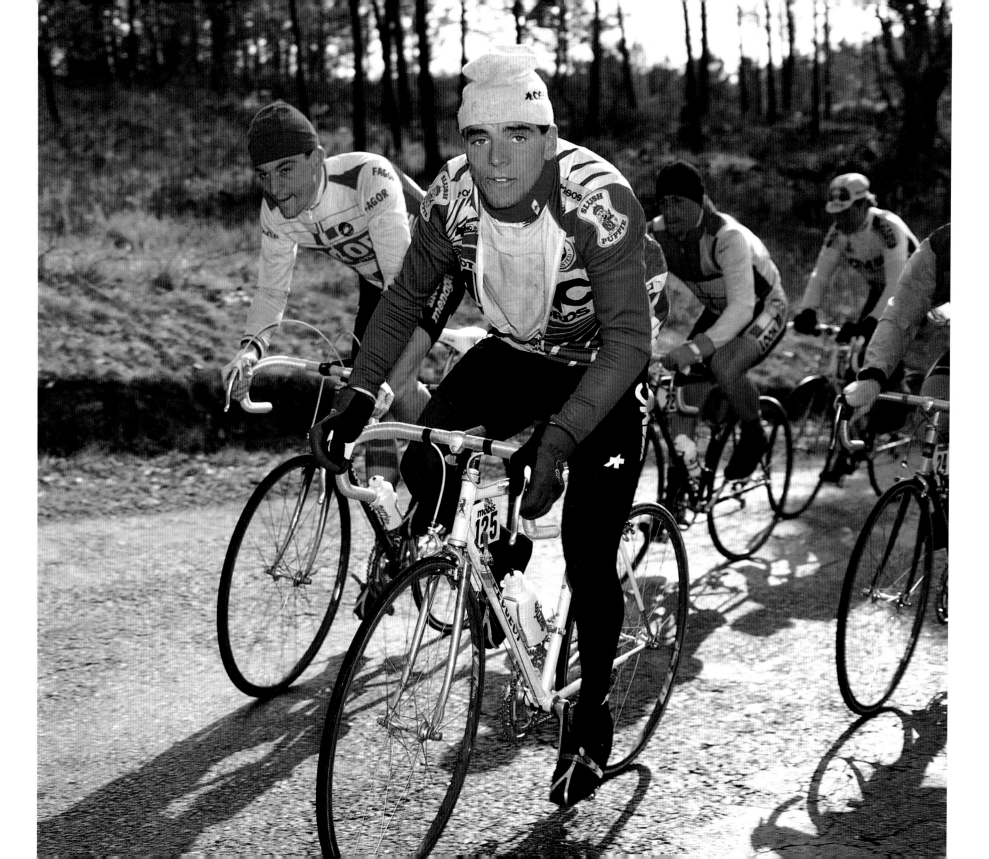

Right: **Joey McLoughlin, Paris–Nice, 1987**
This is another great McLoughlin picture. Full of
energy and expression, his every effort was there
for all to see. This picture was taken on the Col
d'Eze where he was seventeenth on the final time
trial of Paris–Nice. Sean Kelly won the overall race
whilst Stephen Roche won the stage.

Far right: **Joey McLoughlin, Mercian
Ashphalt 2-day, final stage, 1986** It was a
filthy day with wind rain and snow, but Joey won the
stage by more than a minute and took the overall.
Nothing glamorous here but a large crowd came out
to see a very classy performance from the talented
Liverpool lad.

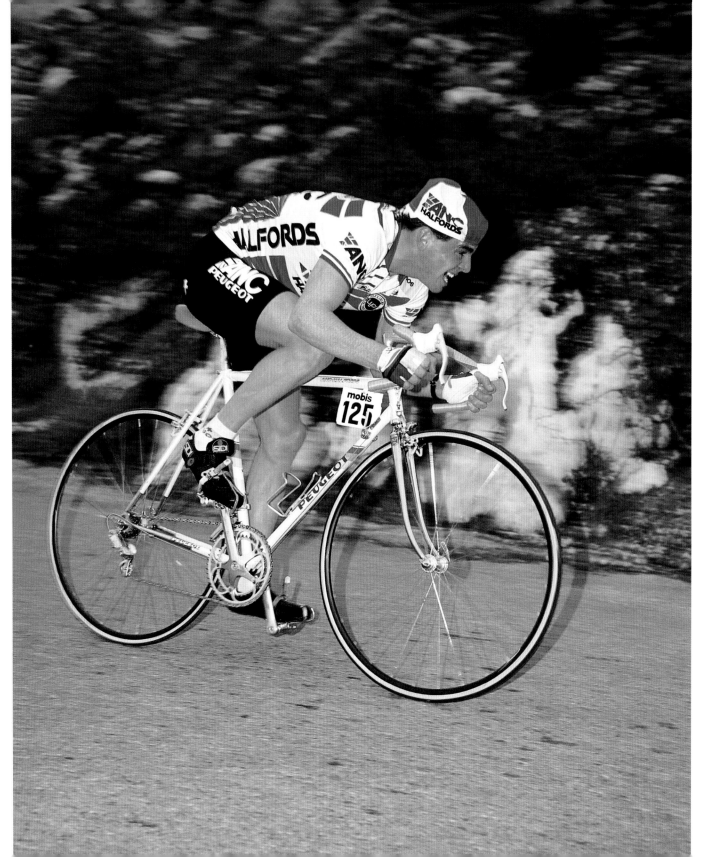

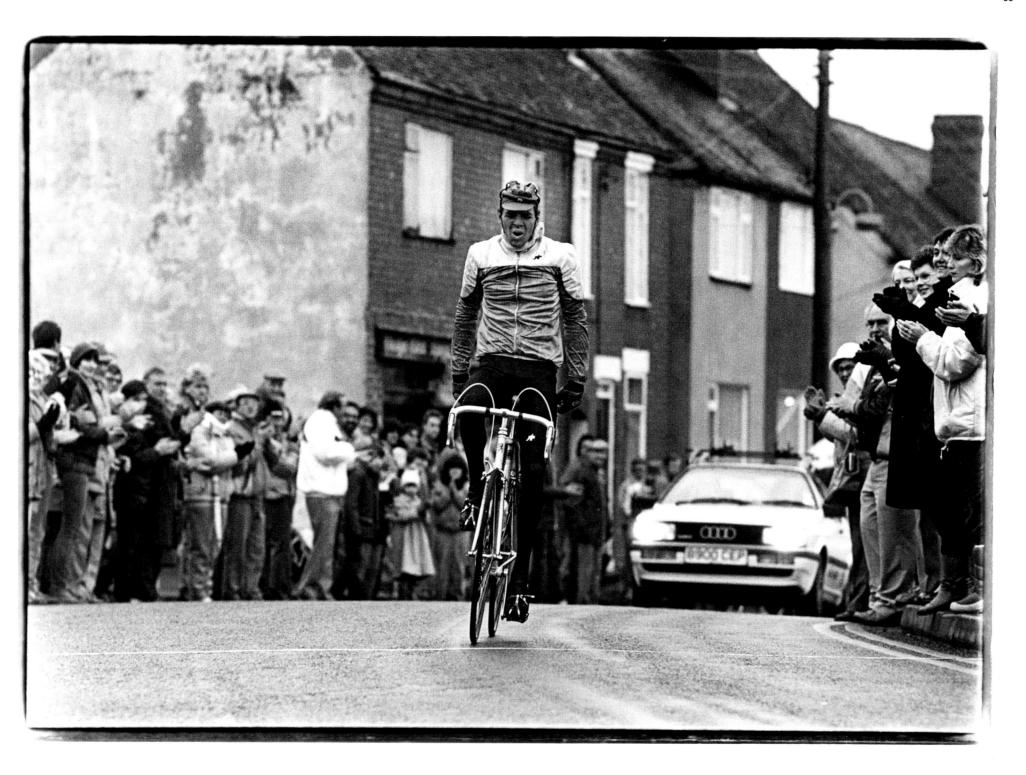

Below: **Shane Sutton, Tour de France prologue, Berlin, 1987** As he waits to start his prologue effort he is seen nervously fiddling with his brake blocks. Shane no doubt was wondering what on earth he was doing here and indeed he was home fairly soon from the event. Ultimately four members of his British ANC team made it to Paris three weeks later. The story of their careers from that moment on were all completely different but It was certainly a life-changing experience and for some of them it was one they could have done without.

Right: **Adrian Timmis, Tour de France, 1987** Amazingly this is the sign-on for the world's greatest bicycle race! Nowadays the whole sign-on procedure is a huge spectacular, witnessed by large crowds.

Below right: **Tony Capper, Tour de France, Berlin, 1987** This picture was taken in the grounds of the Reichstag, where the ANC riders had assembled before the first stage of the Tour. It was already clear from the body language – particularly Malcolm Elliott's – that all was not well within the squad. The riders had realised that the chances of being paid for riding the Tour where slim, which accounted for the negative atmosphere. When I took this photo, ANC boss Tony Capper reminded me of a greyhound owner surrounded by his dogs, waiting to take on all the other owners. The ANC sponsorship collapsed halfway through the Tour, but despite this what Capper achieved was extraordinary. In this day and age you just could not get a team into the Tour de France the way he did. But three short years after starting with a one-man

team of Mick Morrison, Capper forced his way onto the biggest stage in the sport and gave British riders an opportunity which some of them may never have otherwise experienced.

Facing page: **Maclom Elliott & Adrian Timmis, Tour de France, L'Alpe d'Huez, 1987** With Stephen Roche up ahead losing his yellow jersey to Pedro Delgado, these brave lads were grinding up through the heat and the crowds to the top of one of the most difficult climbs in the Alps. For Adrian Timmis this Tour was a race too far. He was never the same again and despite a contract with the French Z-Peugeot team, never realised his undoubted potential. Malcolm Elliott, however, escaped from Paris with his body intact. He went on to have a successful professional career in Spain and the USA.

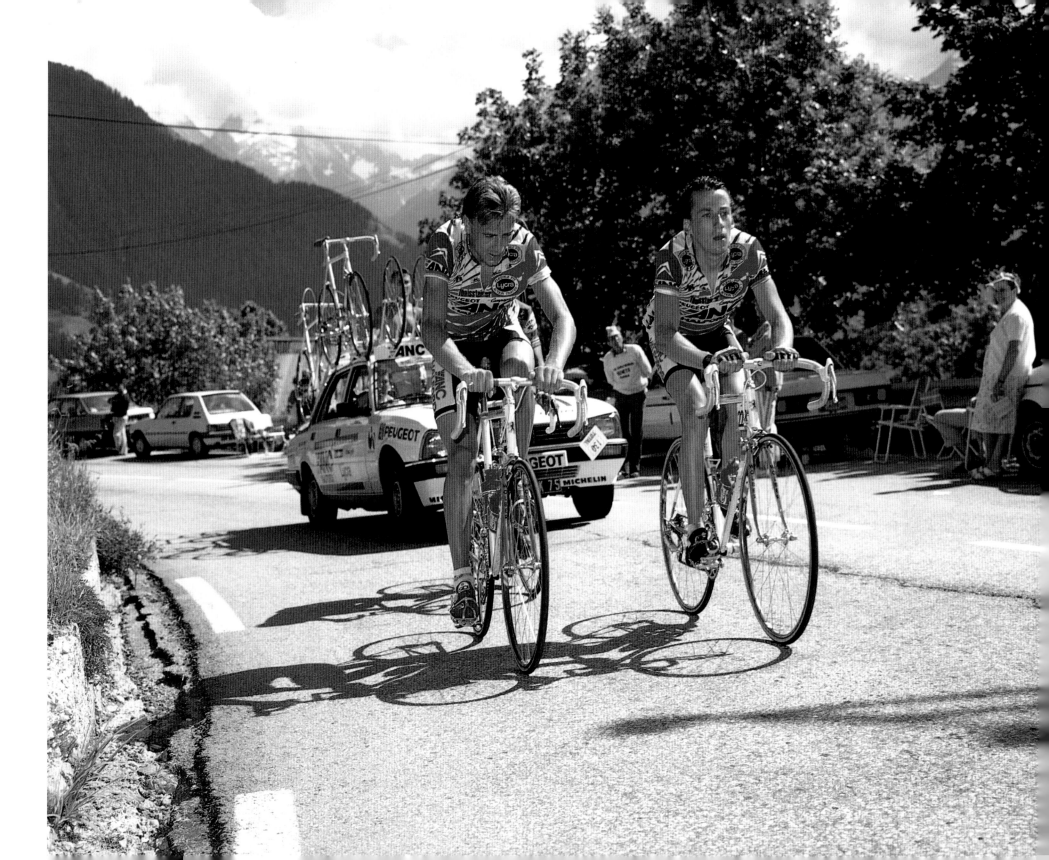

Facing page: **Malcolm Elliott, Winnats Pass, 1986** Despite his natural talent there is no substitute for hard work. Here Elliott is pictured on a training ride, climbing the most feared climb in the Peak District on a misty February morning.

Below: **Malcolm Elliott, Milk Race, 1987** This was Elliott's year in the race that had become a British institution. The Sheffield rider won the first three stages and held the race leader's jersey for the whole race, helped by a strong ANC team. The race itself had moved into a new phase with a few professional teams being invited from 1983 onwards. The previous year Joey McLoughlin had won the Milk Race, the first Briton to do so since Bill Nickson ten years earlier in 1976. Malcolm was

no doubt pleased to keep the race in the ANC camp following Joey's success.

Right: **Malcolm Elliott, Tour DuPont, 1995** Some people just look good in yellow and Malcolm was someone who knew how to wear the jersey. Malcolm rode a good prologue and then won the first road stage that carried a time bonus. Now, before the start of stage 3, he is preparing to go out and defend his leader's jersey whilst trying to look as relaxed as possible.

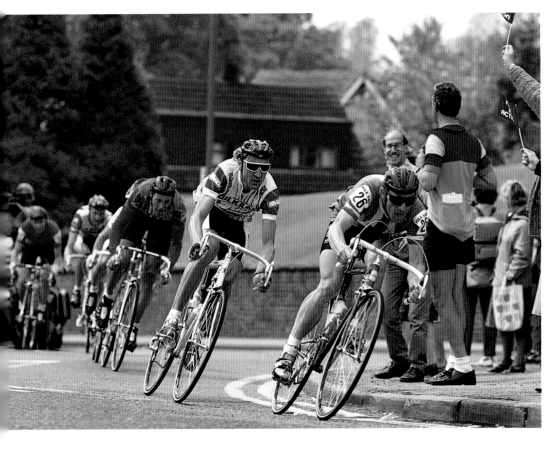

Below: **Yvonne McGregor, Commonwealth Games, Canada, 1994** Victory in the women's points race came as a pleasant surprise to everyone, except perhaps Kathy Watt who had been expecting to win it herself. The field were busy watching the prerace favourite so when Yvonne attacked, few were concerned or even aware of her pursuiting abilities until it was too late. She lapped the field, a performance that was the beginning of an international career that has had as many disappointments as successes.

Below right: **Yvonne McGregor, Hour record, Manchester, 1995** Under the guidance of her coach Peter Keen, McGregor slowly evolved from a triathlete into a dedicated and instantly likeable world class cyclist. The hour record was to be one of her finest achievements. In front of a home crowd she stuck to her intended schedule. At around 40 minutes she hit a sticky patch which the commentator spotted almost instantly and soon whipped the crowd up to help her through before she belted out the last few victorious laps. Later in the year Chris Boardman would also break the hour record under the guidance of Peter Keen for whom it was a justifiably proud moment.

Right: **Yvonne McGregor, Manchester, 2000** After winning her coveted bronze medal at the Sydney Olympics Yvonne returned home to a hero's welcome. In front of a hugely partisan Manchester crowd she swept all before her to add the gold medal of the world pursuit title to her collection.

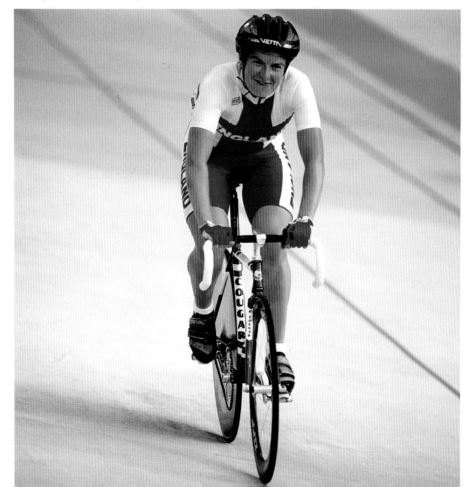

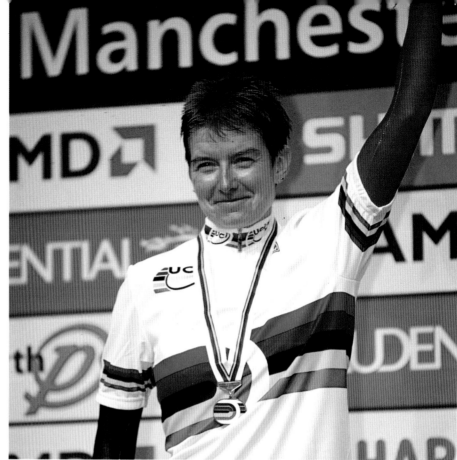

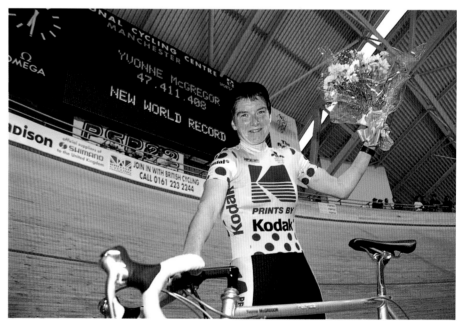

Left: **Daryl Webster, British national hill climb championship, 1985** I took this picture a few seconds after Daryl had crossed the line, running after him to capture his moment of pure agony. Anyone who has ridden these hideous events will know exactly how awful they are! Webster was a controversial but enigmatic star of British cycling in the 1980's, always in the action and always at odds with someone and never afraid to say so. A powerful rider, he won this championship four times from 1983 to 1986.

Above: **Daryl Webster, British national track championships, Leicester, 1985** Here the enigma that was Daryl Webster is receiving advice from Eddie Soens, the legendary Liverpool coach. He was about to ride the pursuit final against Adrian Timmis. The fact that he won will always be remembered at the same time as the fact that Eddie was to die at the age of 75 just five days later from a heart attack. Webster excelled at track, road and time trialling, but he was deemed to be a 'difficult' rider by some managers. He fell out with the British Cycling Federation in 1987 and after winning the Manx International he attempted to justify his position in a speech from the podium, only to be booed by some members of the crowd. Perhaps he was misunderstood, but there was no doubting the talent. After turning pro for an UK based team in 1988, Spanish squad Teka signed him, but he found it difficult to make the transition and his career came to an untimely end.

Above: **David Rayner wins the British junior road race title, 1984** This tall skinny lad went on to become an exceptionally good senior rider who went to Italy to race and ended up getting himself a contract with the Buckler trade team in Holland. The last time I saw Dave was at the 1992 pro race championship in Kilmarnock, Scotland when he came over to me to say hello. We shared a few words and then he was off to the start line. The circumstances of his death in November 1994 still incense me and to this day it still seems so unjust. In 1996 I ran the London Marathon and raised money for the Dave Rayner Fund. When I told people whom I was running for, the donations were always forthcoming and often generous. The Fund continues to be well supported and to this day has helped many British riders realise their ambition to race in Europe.

Above right: **Raleigh team, 1988** *(L to R, back)* Steve Douce, Stuart Coles, Tim Harris, Chris Lillywhite. *(L to R, front)* Phil Thomas, Chris Walker, Dave Mann and the late David Rayner. Walker and Rayner were successful juniors, with Rayner winning the national title and Walker twice winning the season long Peter Buckley series. They continued that success as professionals with Raleigh and other UK teams. What I didn't realise when I took this picture was just how long Dave's arms are, which ended up giving the wrong impression completely!

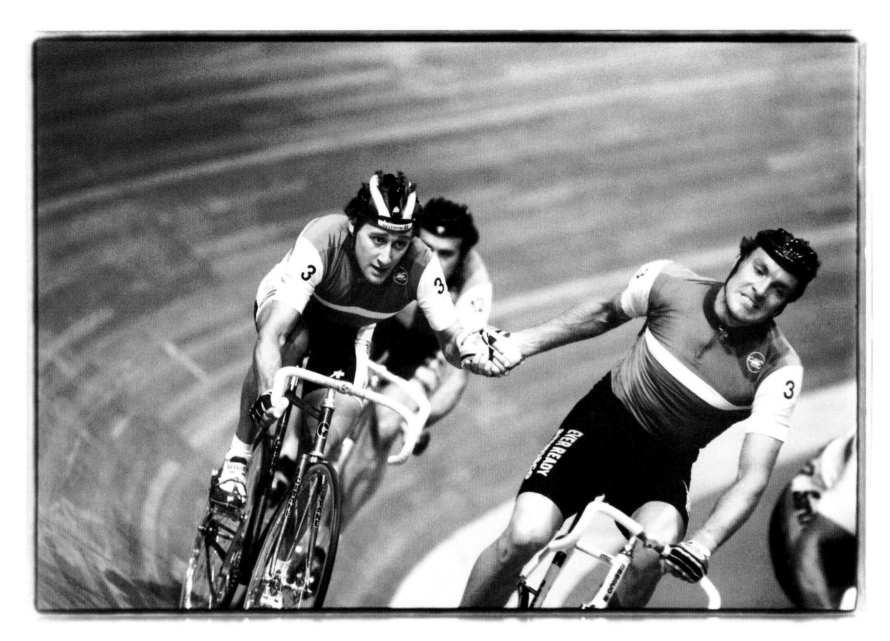

Below left: **Chris Walker, Eastway, London, 1982** The Peter Buckley Series is Britain's national junior championship series. Here, Chris Walker is seen in the last Peter Buckley counting event of 1982 at Eastway. This was the first time that *Cycling Weekly* had asked me to photograph anything for them and it was a big deal at the time. Little did I know at the time that Walker was on the verge of a long and successful career in cycling, culminating in winning the 1991 Milk Race. He also rode as a professional in the USA for the Subaru-Montgomery team along with Rob Holden. If there were a criterium world championships he would surely have won it by now.

Above: **Tony Doyle & Charly Mottet, Paris 6, Bercy** The six-day in Bercy was revived during the early eighties and was held along traditional lines with the teams made up of pairs of track and road riders. Tony Doyle was at the time carving out a very successful career on the winter tracks. In the first Paris 6 he was paired with Stephen Roche who was not only like a fish out of water in the Madison but had the ignominy of having to ride in a jersey with the Union Jack on it! The following year Doyle returned, this time to partner Mottet who was an up and coming star on the French road race scene. The photograph shows the huge strain that the riders have to endure every time they throw their partners into the race.

Above: **Sky TV criterium, Peel, Isle of Man, 1995** This picture captures the tension of a top criterium race with just one lap to go. Rob Hayles, now riding for the Cofidis team, leads the group from Sheffield's Chris Walker, who is poised ready to unleash the sprint which has brought him many wins over the years. Jonny Clay is third and also in the shot are Mark Walsham and Paul Curran, but it was Walker who proved the fastest on the night.

Left: **Pete Sanders, Eastbourne–London, 1986** Looks like a real race doesn't it! Here Pete Sanders has attacked with Dave Lloyd (hidden) on his wheel. For Sid Barras, Paul Watson and Mark Walsham it was the last time that they would see these two. Sadly this is yet another race that no longer exists on the British calendar but at the time it was an early season classic that always produced a good race with a top class winner.

Right: **Kellogg's Criterium Series, 1980s** Alan Peiper leads Joey McLoughlin, Steve Joughin and Phil Bayton. The Kellogg's city centre series in the 1980s was a masterpiece. Great crowds, live television and fantastic racing all with its' heroes and villains. Other series have come and gone but the Kellogg's was undoubtedly the best.

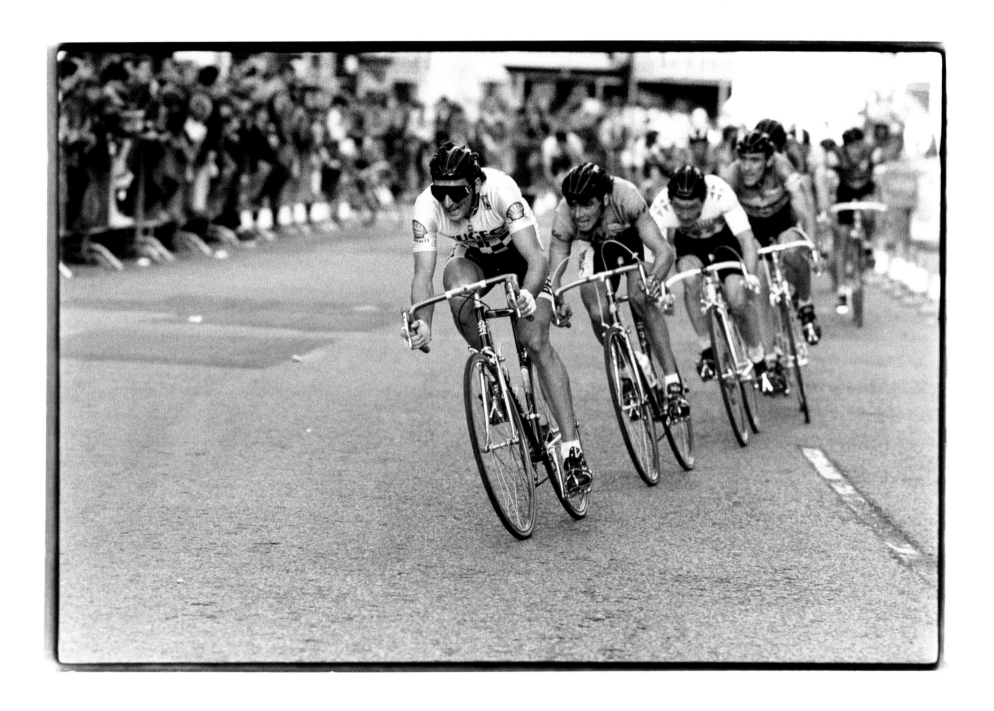

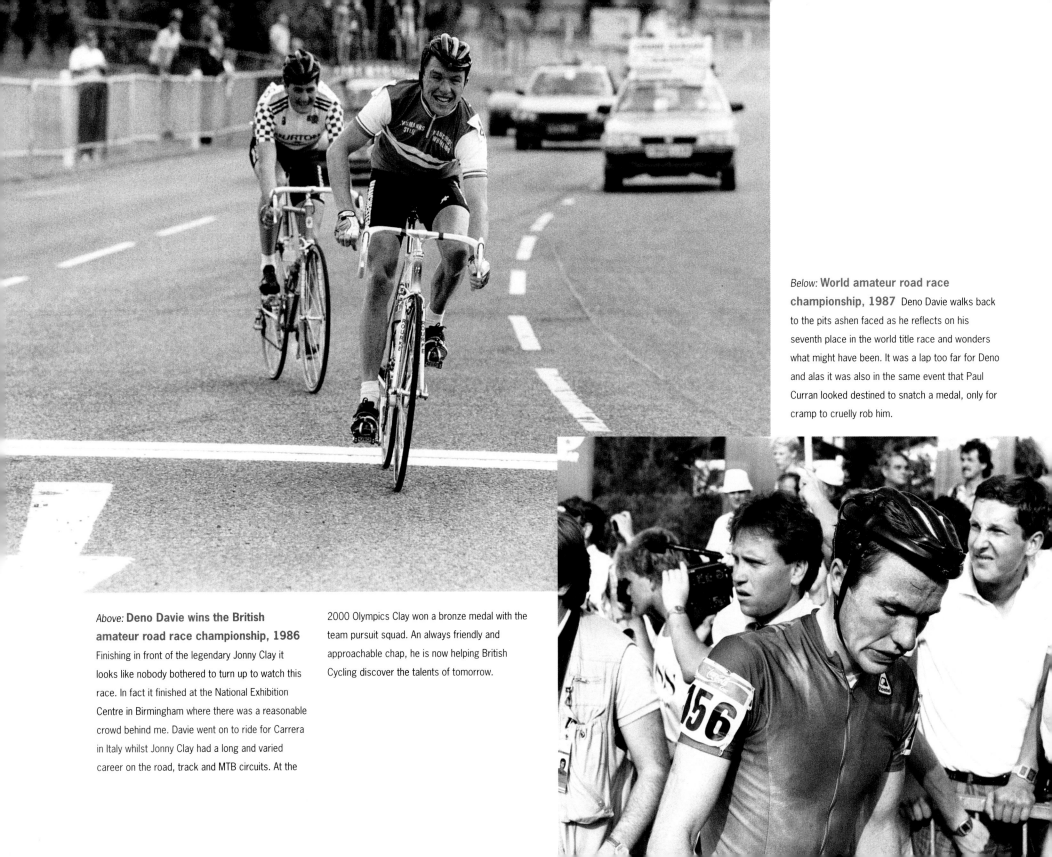

Below: **World amateur road race championship, 1987** Deno Davie walks back to the pits ashen faced as he reflects on his seventh place in the world title race and wonders what might have been. It was a lap too far for Deno and alas it was also in the same event that Paul Curran looked destined to snatch a medal, only for cramp to cruelly rob him.

Above: **Deno Davie wins the British amateur road race championship, 1986** Finishing in front of the legendary Jonny Clay it looks like nobody bothered to turn up to watch this race. In fact it finished at the National Exhibition Centre in Birmingham where there was a reasonable crowd behind me. Davie went on to ride for Carrera in Italy whilst Jonny Clay had a long and varied career on the road, track and MTB circuits. At the 2000 Olympics Clay won a bronze medal with the team pursuit squad. An always friendly and approachable chap, he is now helping British Cycling discover the talents of tomorrow.

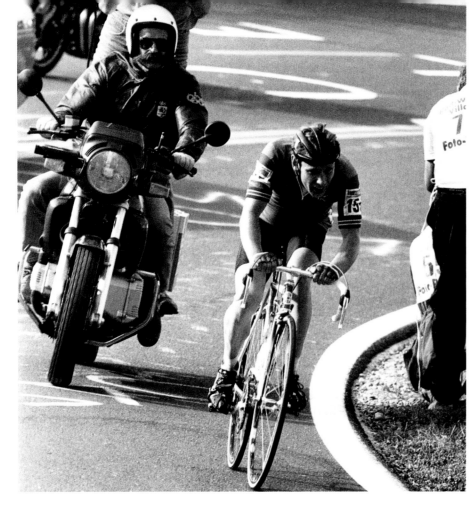

Above: **World amateur road race championship, Villach, Austria, 1987**

Memories of this race probably brings on nightmares for Paul Curran who, at the peak of his amateur career, was in sight of a medal with just two laps to go. Sadly, for the first time in his career he was to suffer cramp which was a bitter pill to swallow. Along with Deno Davie he rode a heroic race, with Deno finally finishing seventh at the back of the lead group.

Right: **Paul Curran, Tour of the Peak, 1987**

This was probably one of the most impressive performances ever in a British road race. Riding at the peak of his powers, Curran let the race unfold until the riders tackled the Snake Pass for the second time. The Teesider then took off alone and caught the break continuing with Roger Dunne for company until they reached the cattle grid at the bottom of Winnats Pass. Roger told me many years later that he congratulated Curran on his ride and bid him farewell at this point; Curran rode alone to the finish over one of the toughest courses in the United Kingdom. It was a precise no-nonsense surgical ride. On the day, he was always going to win. It was just a matter of how.

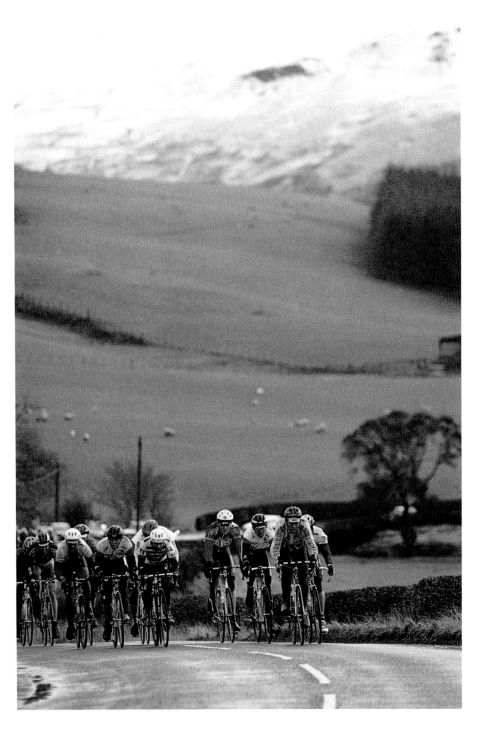

Left: **Girvan 3-day, Scotland, 1994** This race often throws up an unexpected picture and this time I managed to get some snow in the background. Steve Farrell is on the front making it hard for everyone as usual. Although he was an international rider, Farrell worked full-time as a pharmacist. Once, when chasing a break, a professional rider asked why he was not coming through to do his share of the work and Farrell replied "You have to because it's your job, I don't because it's my hobby." You can't really argue with that, can you?

Right: **British national road race championship, South Wales, 1996** Who says dreams don't come true? David Rand, a talented rider from Hampshire, had been making a name for himself in Premier Calendar races throughout 1995 and 1996. He found himself away in the lead with two other riders in the national championships. As the laps ticked by the bunch were not making any impression on their lead and when it came to the sprint down Abergavenny High Street it was Rand who edged ahead to take the biggest win of his career. When I look at a picture like this one I find myself wondering why I didn't get the camera level. In reality I probably had two seconds to get into position and concentrate on the precise moment when the winner's front wheel hits the line. After photographing thousands of races it has become an instinctive process.

Far right: **British national road race championship, West Midlands, 1998** Matt Stephens heads for victory. How many times has he finished fourth in a four-up sprint in a major race? It seemed like Matt was destined to always miss out on the big one, but it all came together for him in 1998 and he was rewarded with the national champion's jersey. Matt is not a sprinter, so he would always have to look for the lone win. Here he attacked with about 15 miles to go and gave it everything he had. Whatever race he was riding, you could bet your house that Matt would at some stage put his head down and make a bid for victory, and being such a strong rider the bunch would soon react to pull him back. On this occasion they gave him an inch and he took a mile and rode his heart out to the line. It was a popular win. I almost missed the finish picture because one of Matt's relatives jumped into the road in the excitement and blocked my view. The bunch steamed in a few seconds later and Matt's team mate Chris Lillywhite embraced him saying the win could not have gone to a better person, the first of many to say much the same thing that day. This picture was taken from the back of a motorbike just as Matt launched his attack. Later Matt was to join the ill-fated Linda McCartney team for whom he heroically rode the Giro d'Italia. A few short months later and the rug was pulled out from under him as the team collapsed.

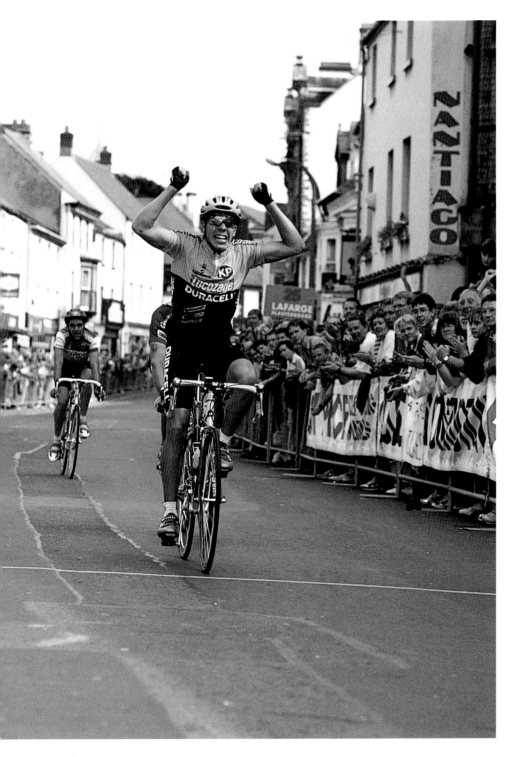

Left: **Record breaking** I got up at goodness knows when in the morning along with Luke Edwardes-Evans to follow Glenn Longland on his attempt to break the blue riband of road records – the London to Brighton and back. This was taken as he approached Brighton. Unfortunately he failed and stopped before reaching the finish line. Road record attempts are largely from a bygone era because road conditions just seem to be so much against them nowadays.

Right: **Glenn Longland breaks the British national 12-hour record, 1986** Taken with lots of flash during the last hour with the record in sight. Glenn was the first rider I witnessed in action when, on my first ever Bournemouth Arrow cycling club run as a 15-year-old, I was taken to see the finishing circuit of the Poole Wheelers 12-hour time trial which he won. A few years later here he was breaking the record. In 1991 he became the first rider to break 300 miles for the race.

Left: **Bradley Wiggins, Eastway, London, 1995** As I took this picture of the juvenile race preceding the main elite event at the March Hare meeting, I had no idea of what was to become of this tall lad. Seven years later he was pulling on the Française de Jeux jersey for the first time as he embarked on a career as a professional rider. As this book went to press Bradley had acquired Olympic, World and Commonwealth medals on the track whilst on the road a promising and long career seems to be on the cards.

Above: **Steve Douce, National cyclo-cross championships, Birmingham, 1988** Douce dominated British cyclo-cross for a decade or more winning the title six times. Here he is seen riding during his peak years as he deftly negotiates an obstacle on his way to victory. One thing that struck me that day was that in recording an event of this nature for publication, it is important to have a selection of pictures of the top riders from around the course with some general views that would give the readers an insight into the event. Another photographer from a daily paper spent the entire hour photographing this obstacle because he had decided (rightly) that this was the best angle of the day and so persevered until he had what he wanted.

Below: **Marie Purvis, Eastway, 1992** There never seemed much point in Marie buying club kit as she seemed to always be wearing the national champion's jersey! Here the Manx woman is seen outsprinting Sally Hodge and others on a grim day at Eastway. Marie was a brilliant athlete who dominated British women's cycling during the nineties and, but for a puncture, would have taken a medal home from the Barcelona Olympics.

Right: **Doug Dailey, Commonwealth Games, Canada, 1994** For me Doug was an all round coach, manager and motivator who lacked any cynicism or hidden agenda. He was a top international bike rider and won the national road title in 1972 and 1976. As a coach his enthusiasm for the sport and the riders was 100%. If he thought something was worth doing for a rider he would do it regardless of the inconvenience it may have caused him.

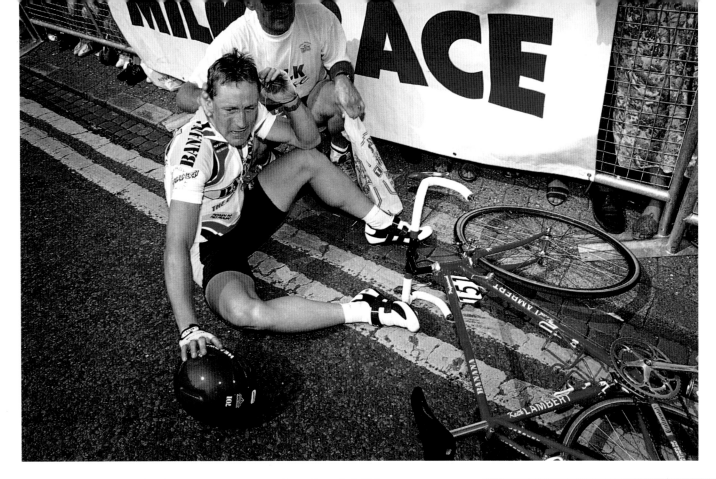

Right: **Kathy Watt, Commonwealth Games, Canada, 1994** It is great when you get the opportunity to take photographs like this. More often than not, the event needs recording for its news value, so the luxury of being able to relax and look for rewarding images such as this one are rare. The racing at Victoria was on an outdoor velodrome and each day there was an evening session. As the sun went down and the shadows lengthened the scope for an artistic angle presented itself. This photo underlines why most photographers prefer track racing on outdoor arenas, but sadly nowadays there are few outdoor venues. In Great Britain the national track championships were held at Leicester for years until they were moved to the new indoor arena at Manchester. It might not rain at the Manchester Velodrome, but the opportunities for interesting pictures have been curtailed.

Above: **Chris Lillywhite, Milk Race, Malvern, 1993** Chris went on to win this, the final Milk Race but as the photo shows it took some considerable effort. The uphill sprint into Malvern left even the best riders gasping for breath on the finish line. At the time a young Nico Mattan, who went on to ride for Cofidis, held the lead.

Right: **Steve Farrell, 1994** This is typical Steve Farrell. He had just taken the lead in the Tour of the Kingdom with one stage remaining. However, convinced that history was about to repeat itself – he told us that the leader's jersey always changed hands on the final day – he did not wait for the end of the race to drink his champagne. Needless to say on the final stage as a breakaway disappeared up the road without Farrell, the bunch came past with the Stoke rider sitting on the back wearing his trademark mad grin. In a reference to the fact that he was no longer race leader he shouted "See, I told you!"

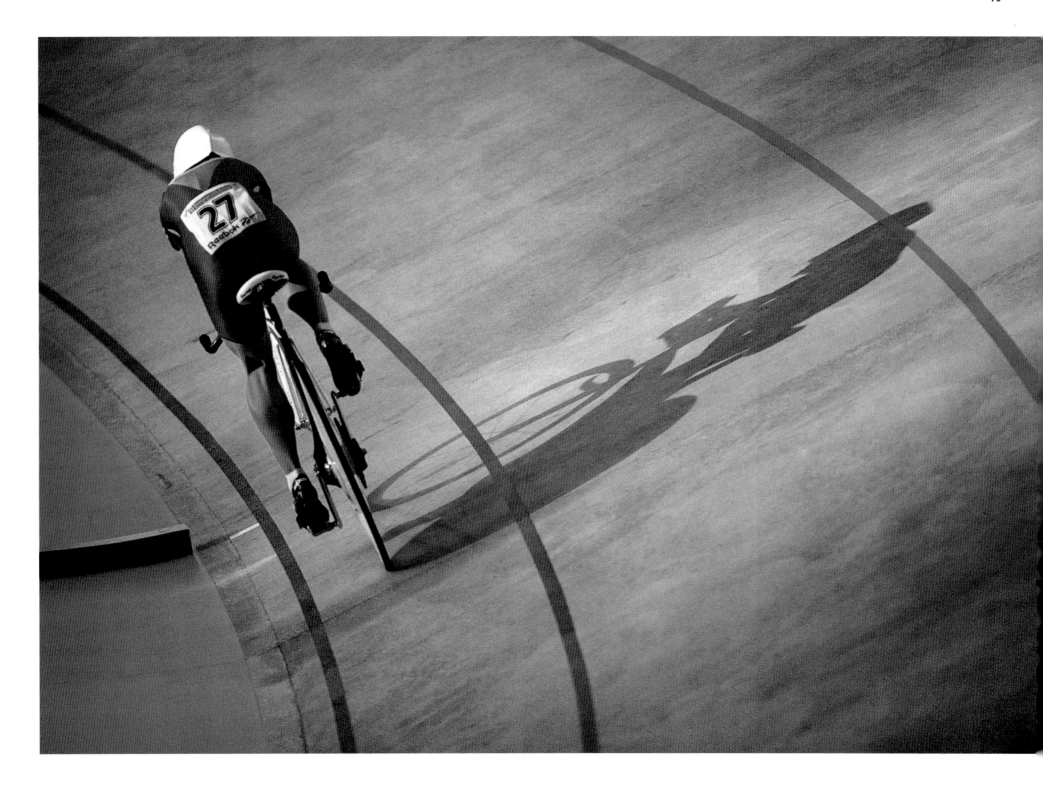

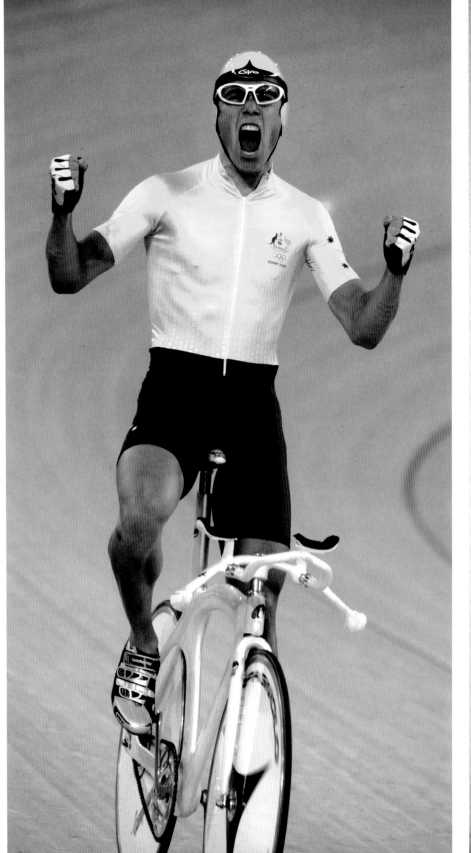

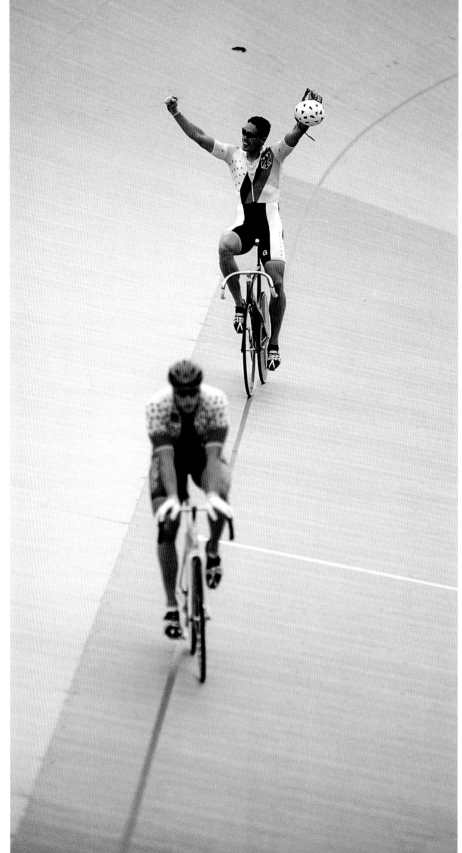

Far left: **Bradley McGee, Olympics, Sydney, 2000** You would think he had won the gold medal not the bronze! Such is the desire of all athletes to win Olympic medals that McGee's reaction to his medal in the individual pursuit is not all that surprising – especially as the event took place in his own country.

Left: **Jens Fiedler, Olympic sprint title race, Atlanta, 1996** For the USA cycling team, the Atlanta Olympics were a disaster. Bike manufacturers GT were funding the squad to the tune of one million dollars and they – as well as all cycling fans in the States – were expecting a handsome haul of medals in return. In the event they had to do with a single silver medal for Marty Nothstein seen here coming second to Fiedler.

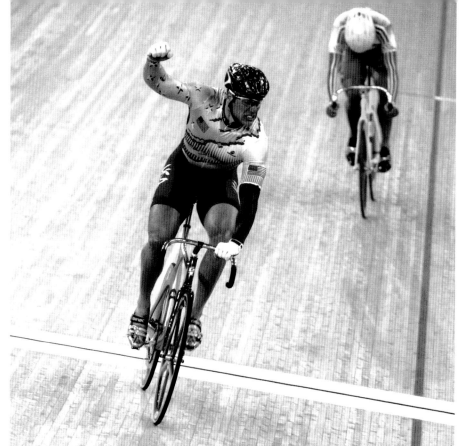

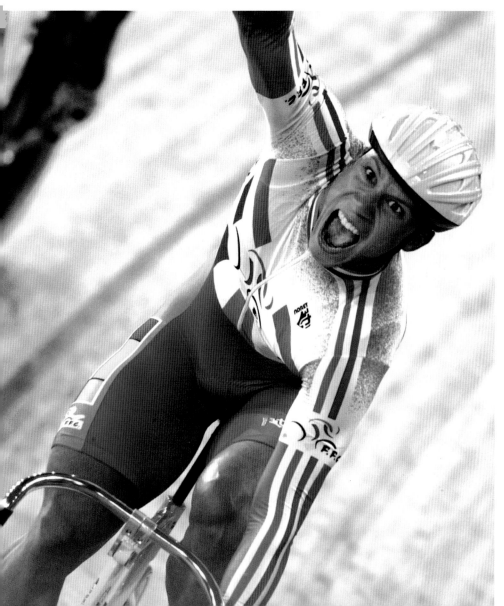

Right: **Florian Rousseau, Olympics, Sydney, 2000** Celebrating his gold medal after winning the kierin, the Frenchman, who had won the kilometere event at Atlanta, gave me a great celebration shot as he screamed into the lens. This was the first time that the kierin had featured as an Olympic event. I was sitting next to a photographer whom I had known for many years and he was quizzing me about this strange event which starts off with a string of riders sitting behind a motorbike. As the motorcycle droned around the track with the line of riders sitting patiently behind it, he looked at me and said "Jeez Phil, this is boring." Four laps later when the motorcycle pulled off and the riders thundered past us four abreast at forty miles per hour, he changed his tune "Blimey Phil, this is fantastic!"

Above: **Marty Nothstein, Olympics, Sydney, 2000** After suffering defeat in the sprint final at Atlanta to the German Jens Fiedler, this was a sweet moment for the huge American sprinter. The sprint is an event which has been dominated by French and German riders in recent years, so for Nothstein to beat Fiedler in the final was sweet revenge indeed.

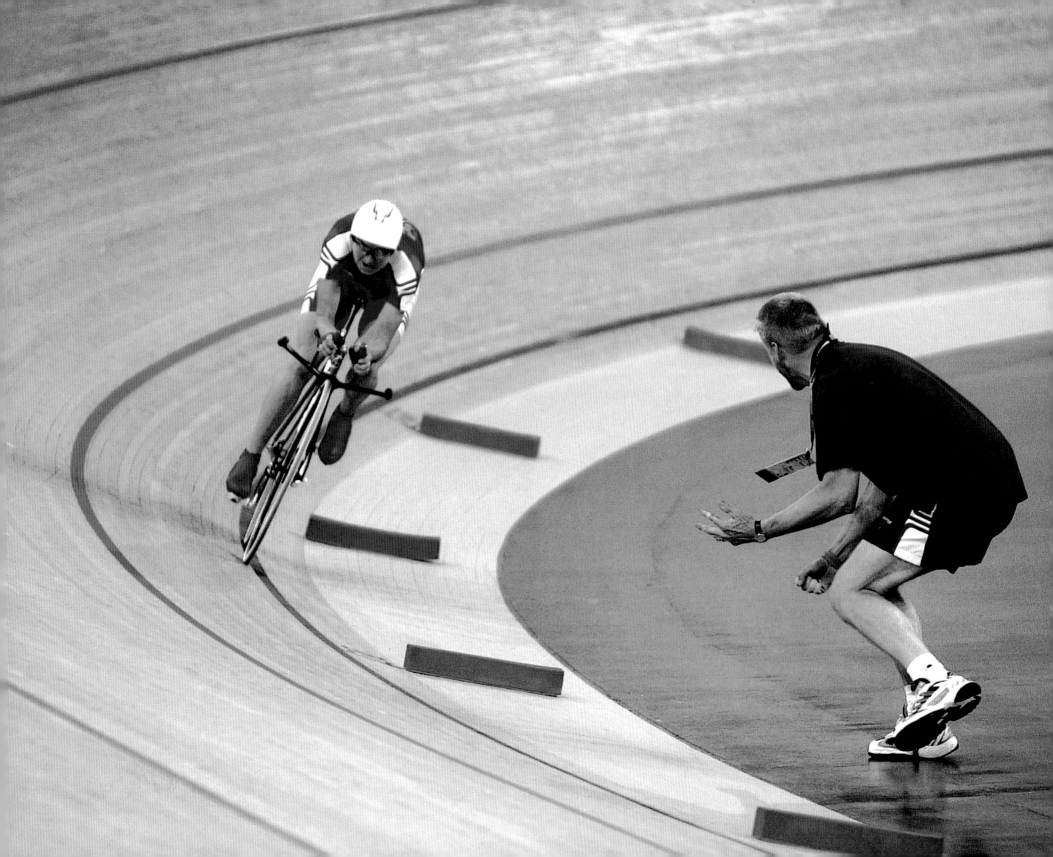

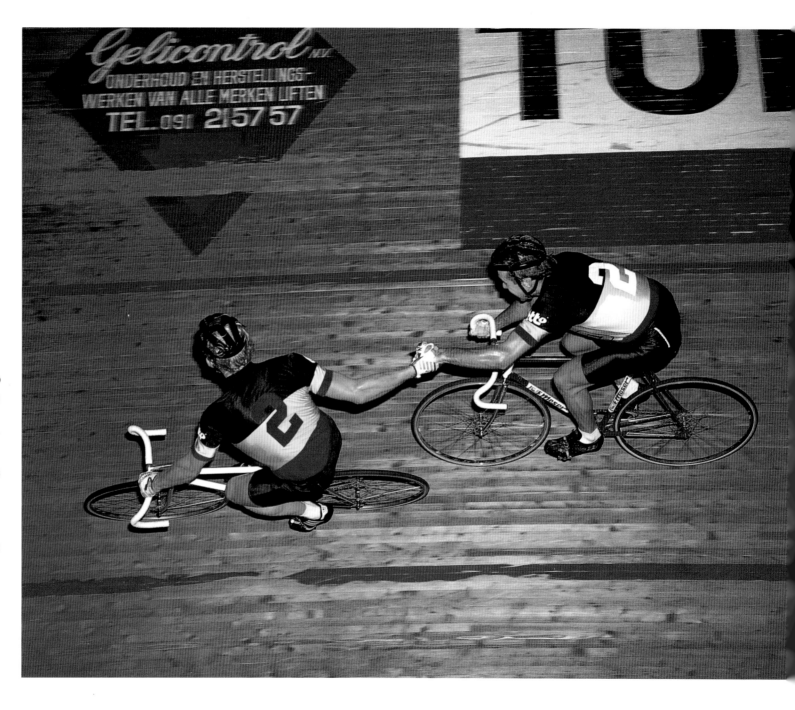

Left: **Yvonne McGregor, Olympics, Sydney, 2000** Dedication personified. Four years earlier McGreggor had lost the ride-off for bronze in Atlanta to Judith Arndt. It was a painful defeat and after the ride as Peter Keen put his arm around her to console her, she pushed him away no doubt feeling as empty as any athlete can in such a situation – fourth place is a lonely place to be. Fast forward to Sydney and again McGregor is riding for the bronze and again with Peter Keen at her side. McGregor started slowly and conceded as much as 1.8 seconds to New Zealand's Sarah Ulmer. At two kilometres to go she looked out of it, having to make up 0.822 seconds and with one to go it was 0.319. She kept her momentum on the last lap and finished in 2:38.85 – just 0.08 seconds in front of Ulmer. Never before has a medal been so richly deserved.

Right: **Ghent 6-day 1986** As the banking is so steep I stood on a chair and was able to get a photo from virtually above the riders looking down on Stan Tourne and Étienne de Wilde as they executed a perfect handsling during the madison.

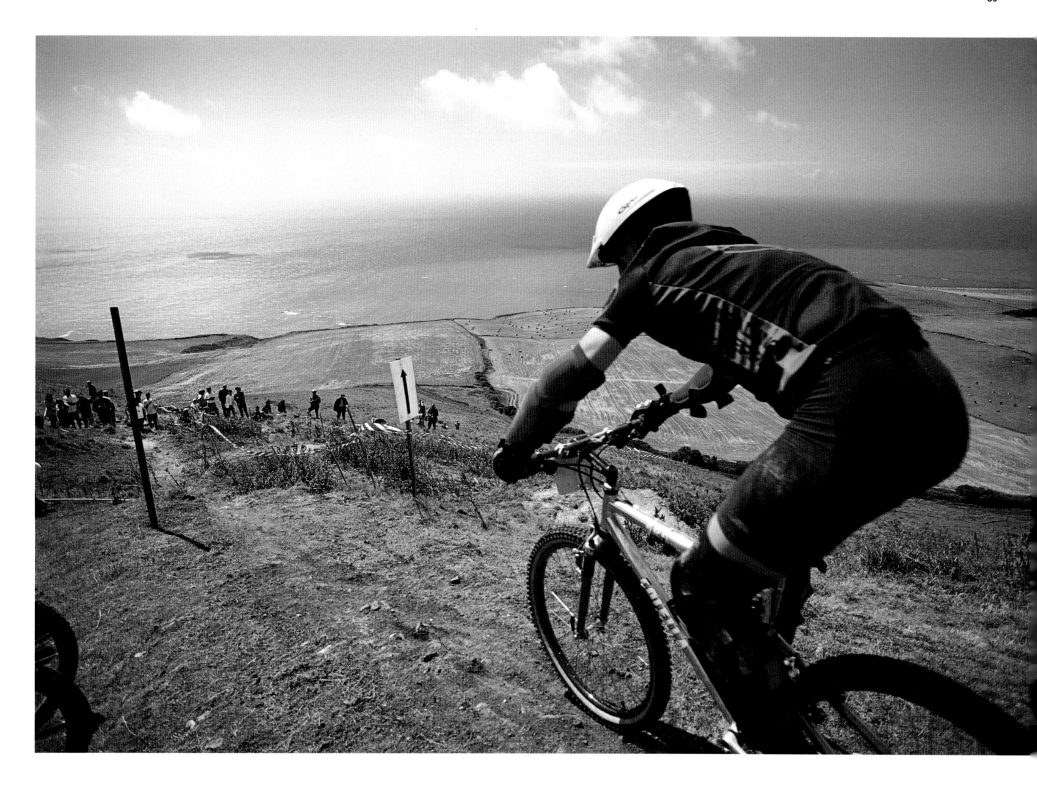

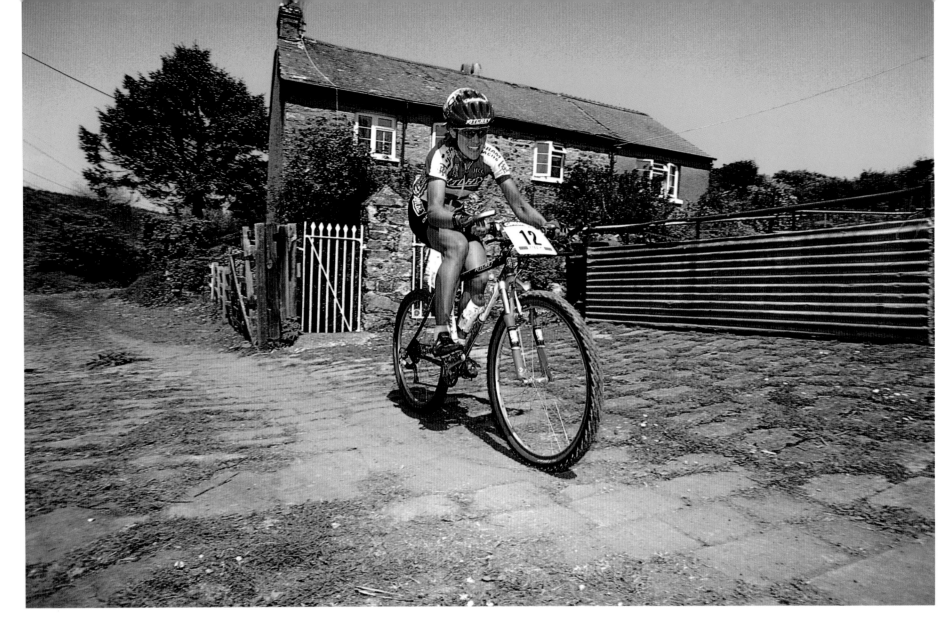

Grundig World Cup, Plymouth, 1998

Caroline Alexander has been Britain's most successful female mountain bike rider for a decade. During that time she has suffered a lot of bad luck, but if there were a trophy for the hardest working rider she would win it by miles. Her capacity for training and her dedication are extraordinary and she can push herself to get the full 100% when racing. Close to the finish of this race, at Newnham Park in Devon, Caroline had a mechanical problem and had to run the last few hundred metres with Alison Sydor closing fast. She held on to the placing. This photo was taken on a blazing hot Sunday on a course designed to give the crowd maximum opportunity to see the riders a number of times on each lap. Mountain bike photography is about trying to get an image of the riders fighting against the natural terrain of the course without the bright course marker tape ruining the picture. I succeeded with this shot because I took it as Caroline rode through a farmyard at the top end of the circuit where there were few spectators.

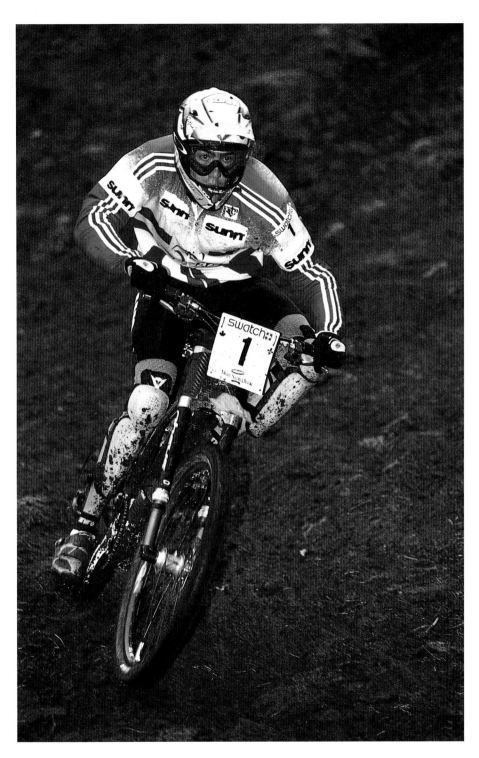

Left: **Nicolas Voulioz, World downhill championships, Mont Sainte-Anne, 1997** Held on a wet, muddy day this was a victory of supreme ability. As reigning champion Voulioz was to go down last on a course that was getting more and more rutted and dangerous as each rider descended. In effect the later you went down the harder it was but still Voulioz won. For me it was also something of a personal triumph. I was still working with non auto focus lenses which made trying to get sharp pictures with the lens wide open a bit of a challenge, especially when you only get one hit as the rider hurtles past.

Below: **David Baker, National MTB championships, Scarborough, 1992** On what was an almost unridable course, David Baker triumphed. Here at the finish team manager Mick Morrison removes half of the countryside from his eyes while Baker's future wife Grace looks on. During the nineties, as mountain bike racing developed a World Cup circuit, David was able to show a wider audience just what a classy bike rider he was. An absolutely fearless descender and an expert bike handler, he is one of the best cyclists that the North of England has ever produced.

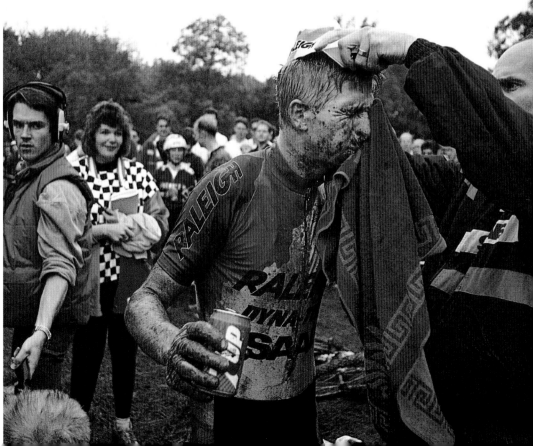

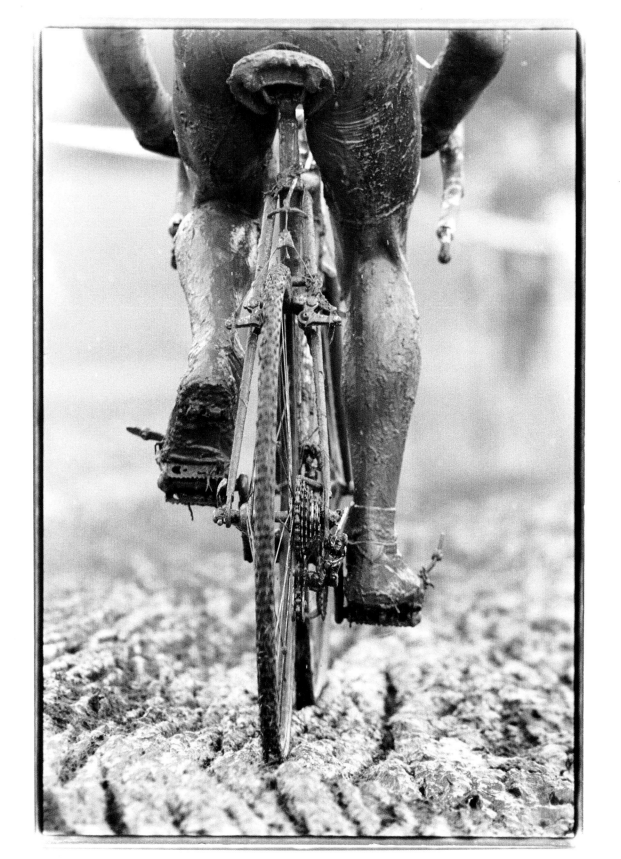

Left: **World cyclo-cross championships, Belgium, 1986** Run in an almost total mud bath, this was one of the few sections where the riders could actually ride their bikes. For most it was a running race with bikes on their shoulders. I remember that this was the first time I had used my brand new 300mm f2.8 Nikon lens – something I had coveted for some time. It felt like the Rolls Royce of lenses as I used it. Now it sits in a cupboard at home gathering dust, reliving memories of races in all four corners of the world.

Right: **Barrie Clarke, Maryon Wilson Park, 1994** This is a real photographer's picture. I spent quite a while trying to get the right combination of rider and angle. In the end Barrie Clarke's National cyclo-cross champion's jersey fitted the bill perfectly. Barrie is one of Britain's most consistent riders. He has won the climber's jersey in the Milk Race and is known as a prolific winner of cyclo-cross and mountain bike races. He was prominent in the early years of world cup mountain bike racing with countless top ten rides to his credit. A team manager once said to me "If only I could have a team of Barrie Clarkes, my life would be so much easier".

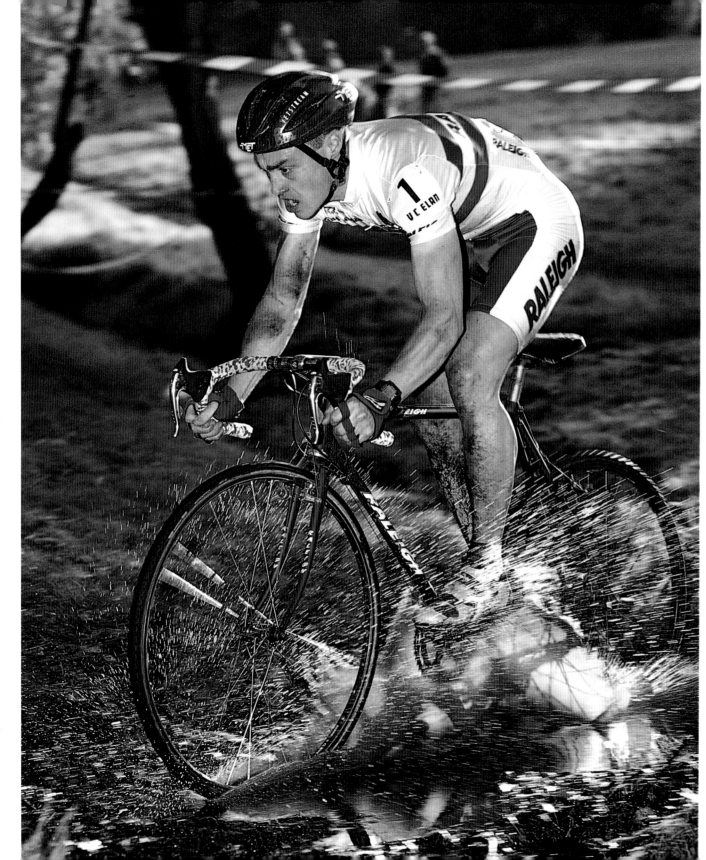

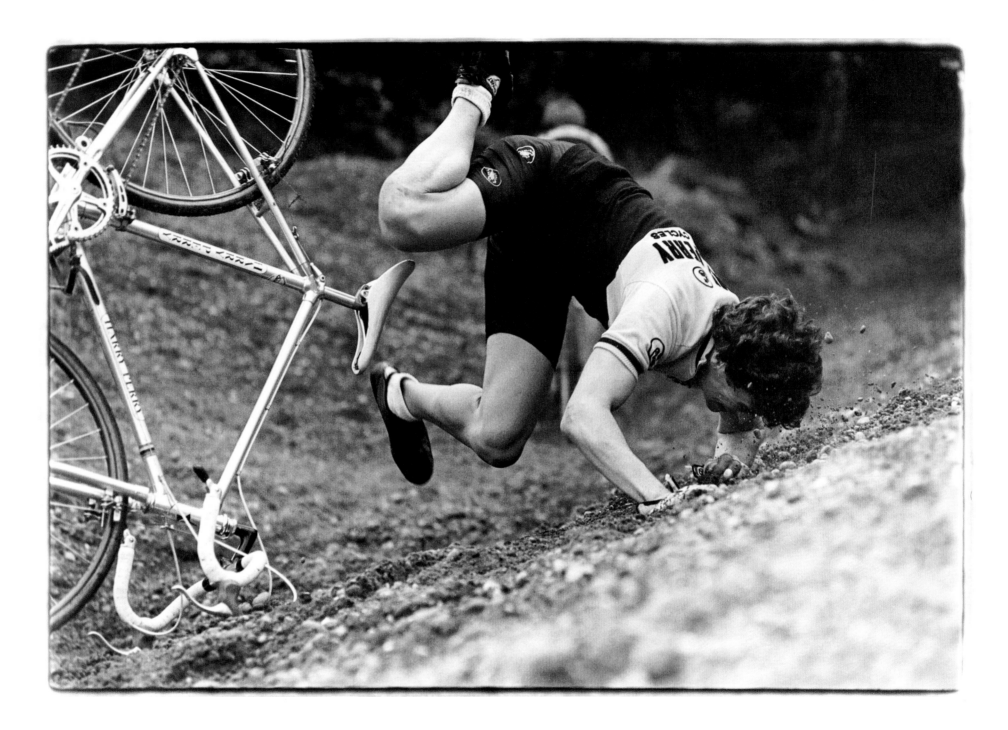

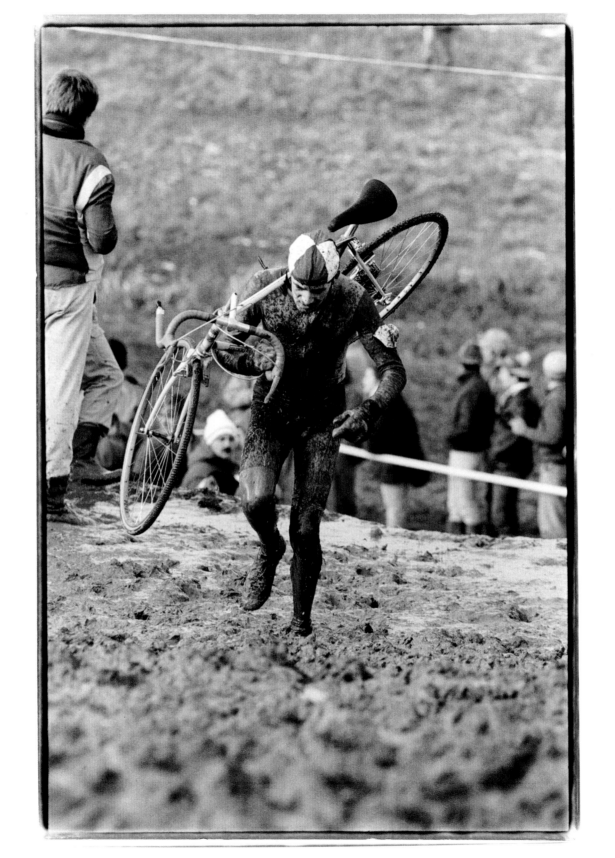

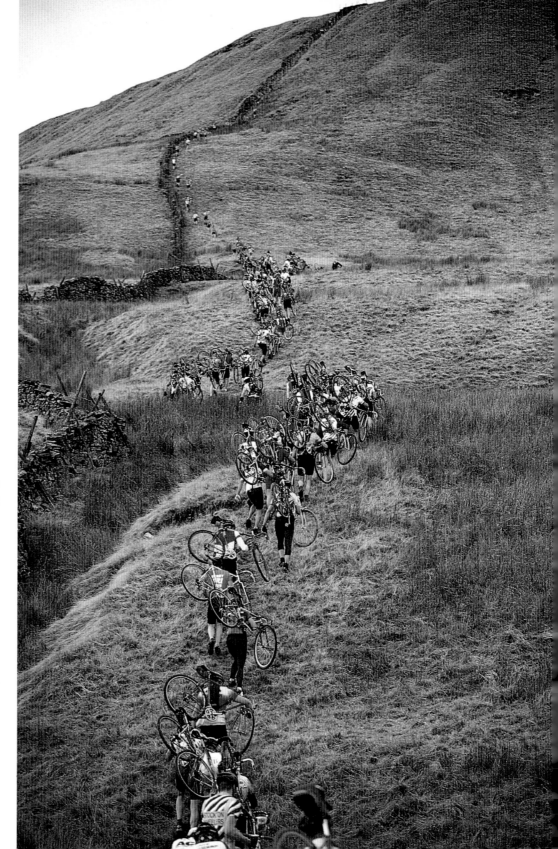

Left: **A British world champion** Stuart Marshall runs to victory at Lembeek, Belgium, in the 1986 junior world cyclo-cross championships. Great Britain has had little success at world level so this gold medal was a defining moment. 14 years later Roger Hammond was to lift the same trophy at Leeds.

Right: **Three Peaks, cyclo-cross, 1999** The last time I had been at this race was in 1984 when I rode it. Fifteen years later, as I took this picture of the riders shouldering their bikes to the top of Ingelborough, it made me wonder how I managed it. Think about it: Ingelborough, Whernside and Pen-y-Gent. Any one of them would be tough enough, but all three, in one day, on a bike? It's absolute madness, but a fantastic achievement for everyone who manages to finish it.

Page 94: **Unknown rider crashing at Shirley Hills cyclo-cross, 1982**

Page 95: **Addiscombe cyclo-cross, 1982** This was on a course near Westerham in Kent. Over the years cyclo-cross has often presented me with some favourite images. There is no traffic or annoying backgrounds to contend with so these events lend themselves to a rewarding photographic experience.

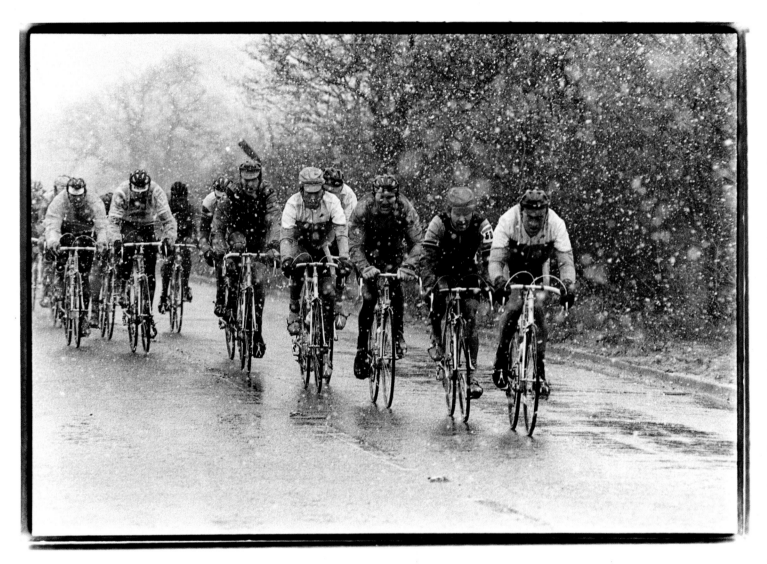

Left: **Mercian Ashphalt 2-day, 1986** Steve Jones followed by Jack Kershaw, Bob Downs and Graham Jones leads this quartet of tough British professional riders. Both of these unrelated 'Jones boys' had raced in continental Europe as professionals – no doubt developing a level of hardness which made days like these all the more bearable.

Right: **Manx International, 1996** This was taken on the first hairpin after the leaders have left Ramsay to climb the mountain for the third time. This corner lends itself perfectly to a 20mm lens and some vibrant 50asa Fuji film. The Festina rider is Australian Steve Hodge. He is at the point of the climb where the cracks begin to open and those with tired legs submit to gravity and slide backwards. Soon the riders will emerge from the trees into bright sunlight to tackle Snaefell and the mad, white-knuckle descent to the finish at the Grandstand. This remains the only race in Great Britain to be run on completely closed roads each year. The Manx International – and the races which run concurrently with it, the Viking Trophy and the Mannin Veg – use the famous motorcycle TT course and remains one of the toughest challenges on the British cycling calendar.

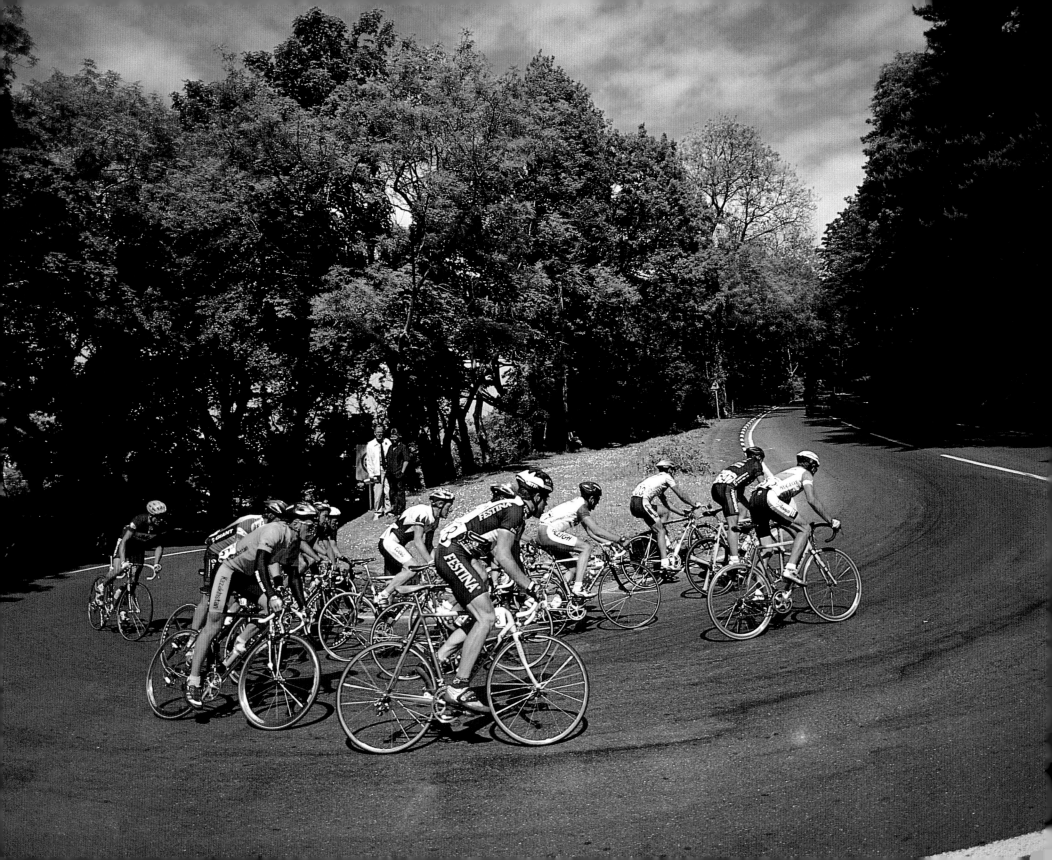

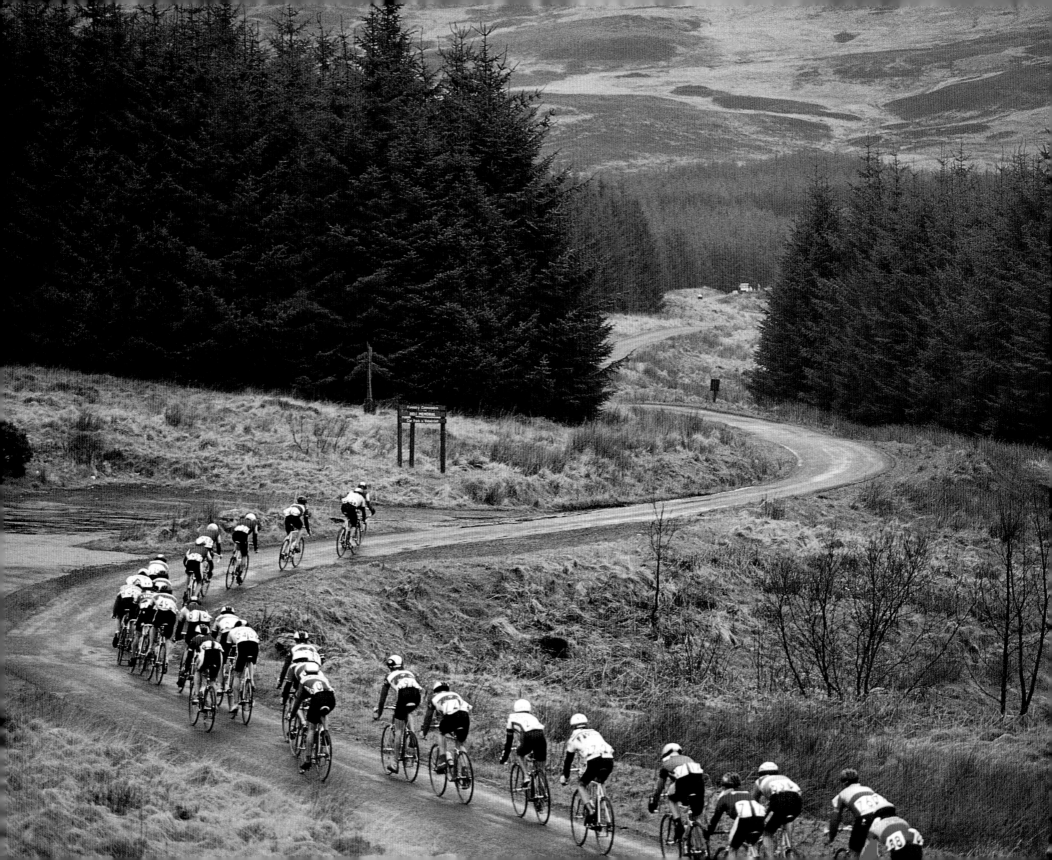

Facing page: **Girvan stage race, Scotland,1992** Quiet roads, stunning scenery and a great bike race. Unfortunately for me this road with its firs and heathers is no longer used. Various district councils now sponsor the Girvan so the race is routed through those councils' areas. The council covering this area is no longer involved so now I don't get to take photographs here.

Right: **Milk Race, Northeast England, 1987** Talk about 'We didn't know what we had until we lost it!' The Milk Race ran for 35 years and was the cornerstone of British cycling. Any rider of note would base their season around getting a ride in this two-week race held at the end of May and into June. It went over some of the toughest and most beautiful roads in England and Wales. Many of the sport's most talented riders rode it before becoming top professional riders. For cyclists from the eastern bloc who were unable to turn professional, the Milk Race was a major feature in their cycling calendar. This picture was taken on a stage from Newcastle to Newton Aycliffe. Philippe Casado and Philippe Louviot had broken away with Miroslav Sykora. Ultimately they were caught and Malcolm Elliott sprinted in to win his second stage in two days. Sadly less than eight years later Casado, who went on to ride four Tours de France, died at the age of 30 whilst playing rugby at his home in the Pyrénées.

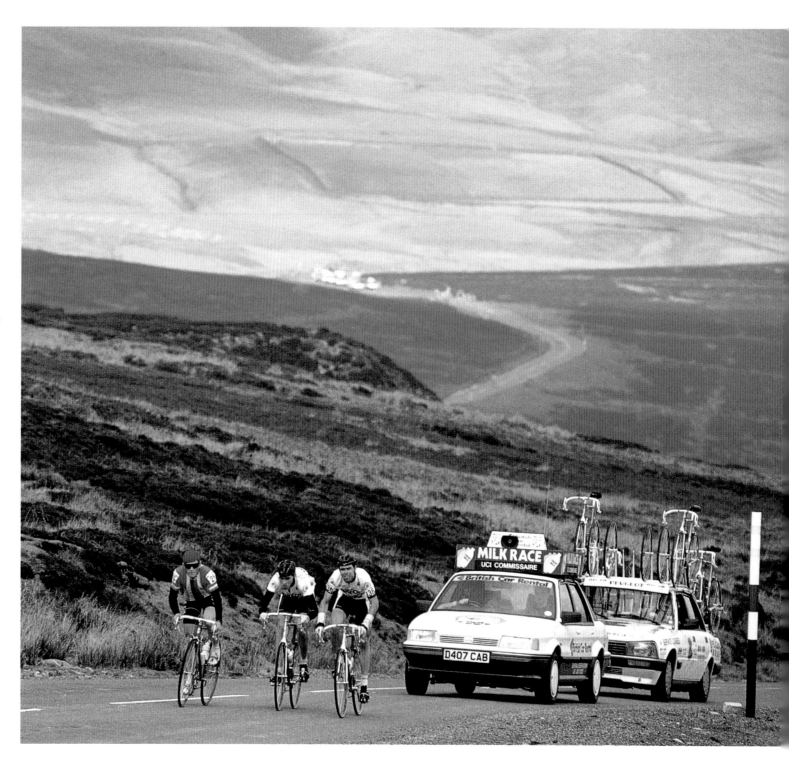

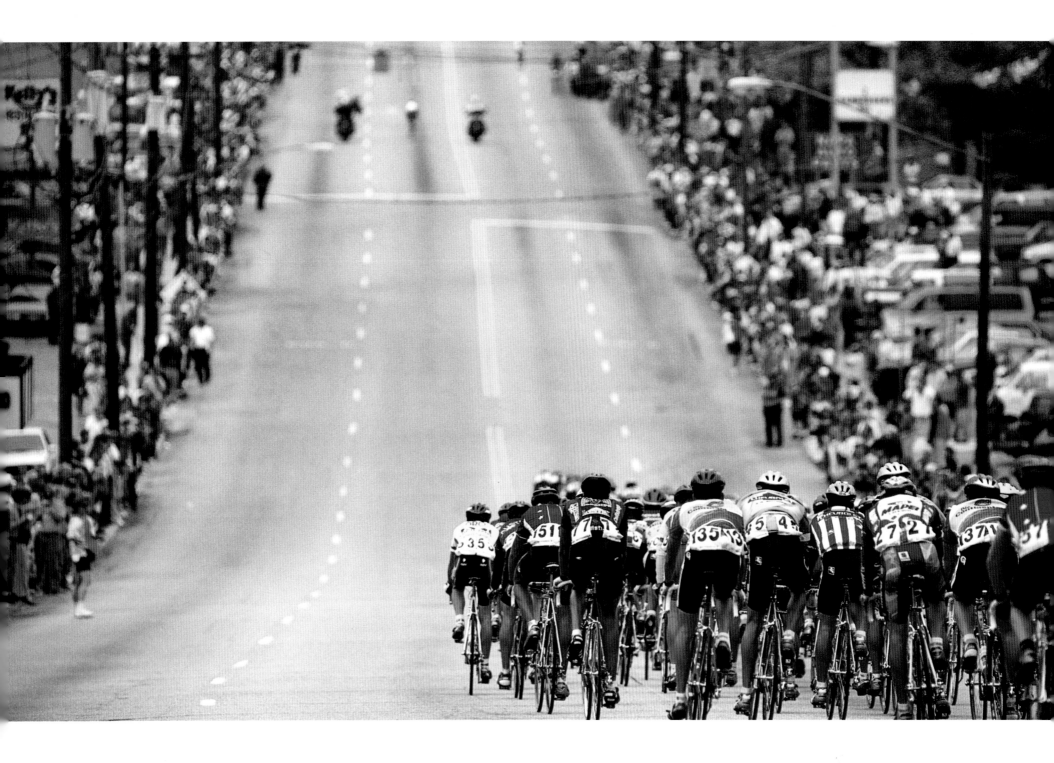

Left: **Tour DuPont, 1995** This was the first and last time I went to this race. It started in Wilmington, Pennsylvania and finished 10 days later in Charlotte, North Carolina. Lance Armstrong was the winner after an incredible ride to Beech Mountain which allowed him to clinch the overall lead. The yellow lines give away the uniquely American nature of this shot. Captured on a 300mm lens it is one of the images that you see before the race arrives. I would spend a few moments getting into the right position and then all I had to do was wait for the race to come along and fill in the missing gap.

Right: **Het Volk, Eikenburg, 1982** Gregor Braun leads this break along with Jan Raas and Roger de Vlaeminck. These were early days for me and to see riders like de Vlaeminck in action was fantasyland. These days soon pass however and once you have come to terms with your role in the sport as a photographer the jaw no longer drops as they pass. You just get on with your job. Years later I was at the Tour of Murcia with two budding journalists. The three of us were talking to Jeremy Hunt before the start when Marco Pantani cycled by. I suddenly realised that my two colleagues had completely lost control of their jaws as they stared in disbelief in the little Italian's direction.

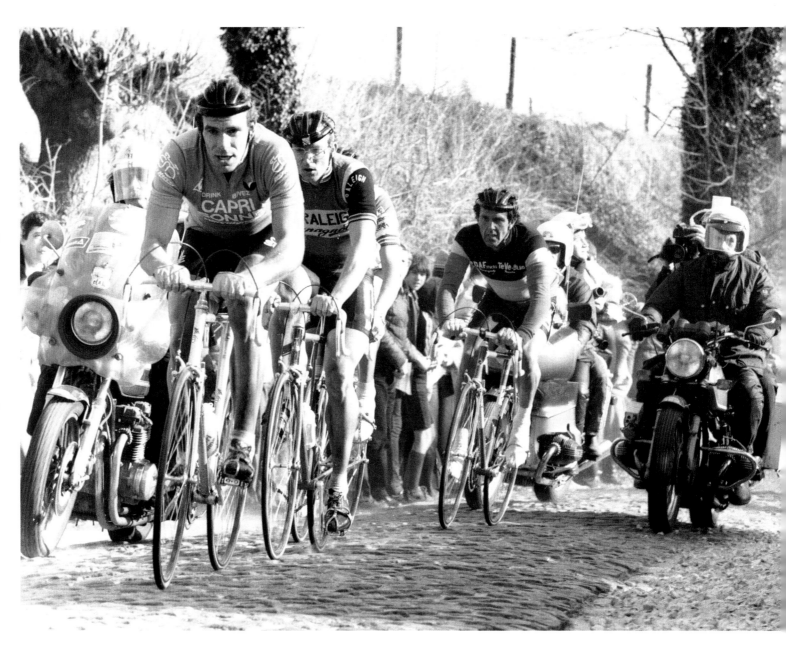

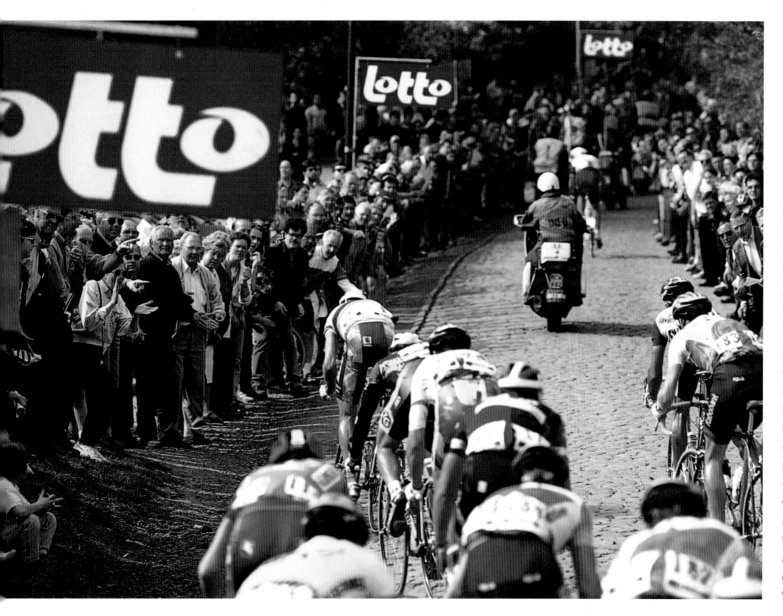

Gent–Wevelgem, Kemmelberg, 1998 I
went to this race trying to get a photo which
captured the passion that the Belgian people have
for bike racing and its stars. Gent–Wevelgem is
smaller than the Tour of Flanders, which is probably
their biggest sporting day of the year, but it still has
a large following and is highly regarded among
Belgian riders. The photo shows the bunch as they
have just turned left off the tarmac to start the
climb onto the Kemmelberg for the first time. As the
riders head for the gravel at the side of the cobbles
it is essential to be amongst the first onto this climb
because it is very difficult to make up any ground
once you are on the steep cobbled gradient. The
rider leading the charge – and wearing number one
– is the hero of Flanders, Johan Museeuw, who was
world road race champion at the time. The crowds
are watching intently for the stars and trying to pick
them out as they flash by. Peter van Petegem is
also visible as is Andrei Tchmil, riders who know
each other inside out. The race was won by Franck
Vandenbrouke.

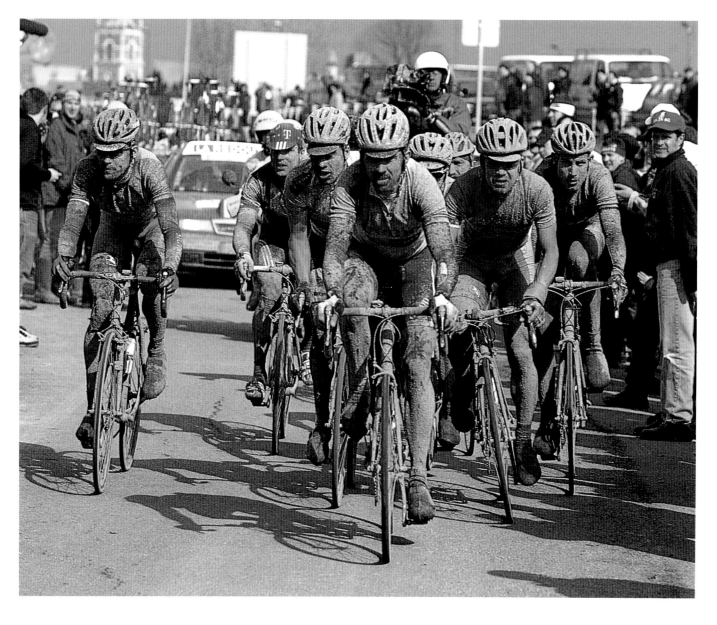

Paris–Roubaix, 2001 Every now and then there is a Paris–Roubaix that the riders hate and the photographers love. This was one of those. Interestingly whilst this is my favourite picture from a particularly muddy race it was not taken on a cobbled section. It was taken at a point where the traffic had been stopped to allow the race through. Being such a large traffic jam I couldn't travel further, so I went down to take a picture without realising I was going to be presented with such a dramatic image. The riders had been caked in mud since the first section of cobbles when many had fallen. A strong group of potential winners had then formed at the front with many miles still to go and here they all are, almost indistinguishable. The contrast of the sunlight on these mud people gives the picture the quality that it possesses.

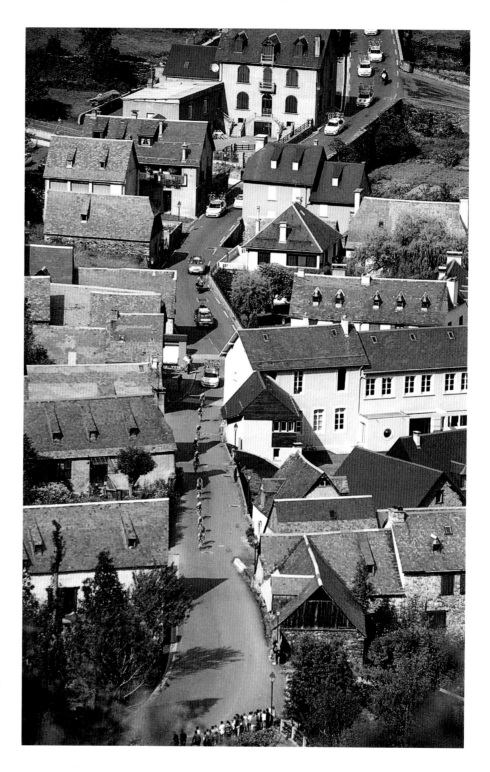

Tour de l'Avenir, 1997 This sleepy little Alpine hamlet is bathed in September sunshine as the peloton containing some stars of the future speeds silently through.

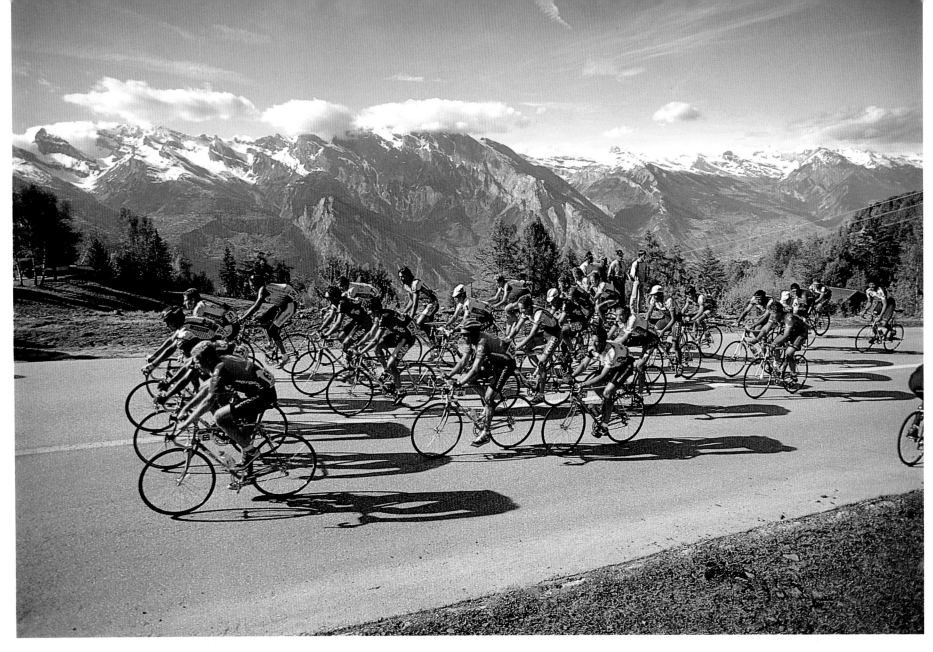

Tour de Romandie, 1995 Okay, so this is the final group, but it still ranks as an all time favourite photo as the setting is just perfect. To me, the mountains are always beautiful but these riders, and others like them at the tail end of any race, don't share my enthusiasm for the surroundings. The only thing on the minds of this group will be getting to the finish before the time limit so they can start tomorrow's stage. The 'Autobus' or 'Laughing Group' is the ironic name given to the last bunch of riders on the road, but study any picture of the tailenders and you will be hard pushed to detect anything approaching a smile, let alone a laugh.

Tour de l'Avenir, Col de la Colombiere, 1997 On the previous day's stage, David Extebarria had taken the jersey in freezing conditions that saw half of the bunch abandon. This group represents all those that remained for the final stage to Morzine. The Tour de l'Avenir was for a long time an amateur race and considered the little brother of the Tour de France. In the early eighties it was opened up to professionals and since racing went 'open' it has come to be seen as a real testing ground for future Tour contenders. Greg LeMond and Miguel Induráin are two former l'Avenir winners who went on to repeat their success in the big one.

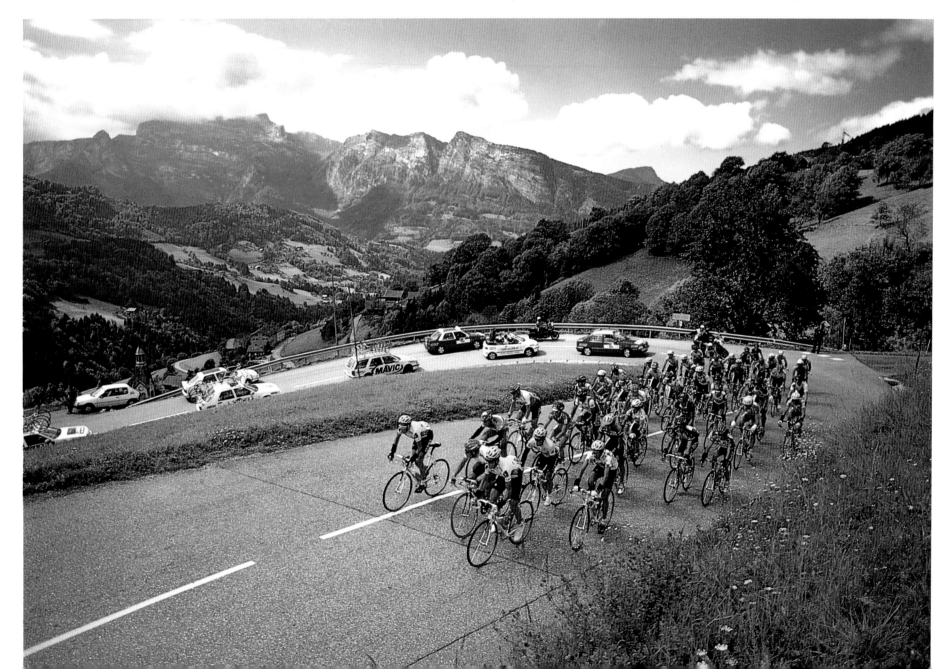

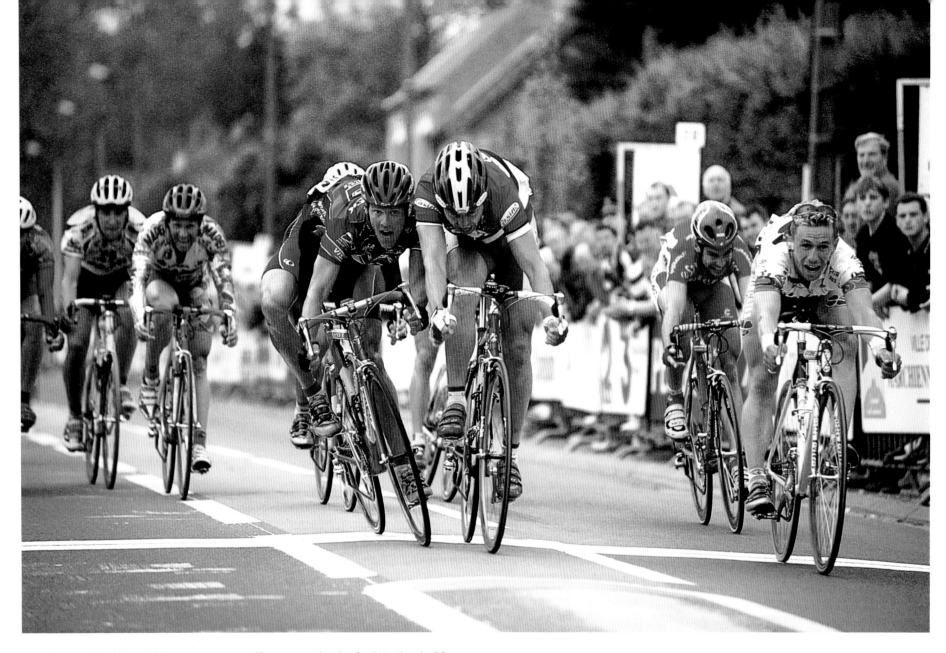

Four Days of Dunkirk, 1998 I got lucky here. It was a dead-straight wide road that greeted the sprinters at the end of this stage from Béthune to Marchiennes. Following the sprint in by eye, I naturally went to Jaan Kirsipuu, the Casino rider in the yellow helmet at the centre of this picture. He was having a battle royal with US Postal's Glenn Magnusson, and as they fought tooth and nail for the line, they were as oblivious as I was to Jimmy Casper sneaking up on the far right of the picture. The diminutive La Française de Jeux sprinter took the win by inches.

Crédit Agricole training camp near Pau, France, 2000 I have been to countless training camps and group shots often make for artistic pictures, but this was one that I could not resist. The squad was in the middle of a five-hour ride, having done two hard sessions the day before. Some of the team were away in Australia riding the Tour Down Under with Roger Legeay, the team manager. The remainder were left in France under the control of another director and the word was that he was terrified of Legeay returning to find the riders anything other than fit, so he was going to get them in shape with whatever it took. If you look closely, you can spot a club rider who has joined in with the team!

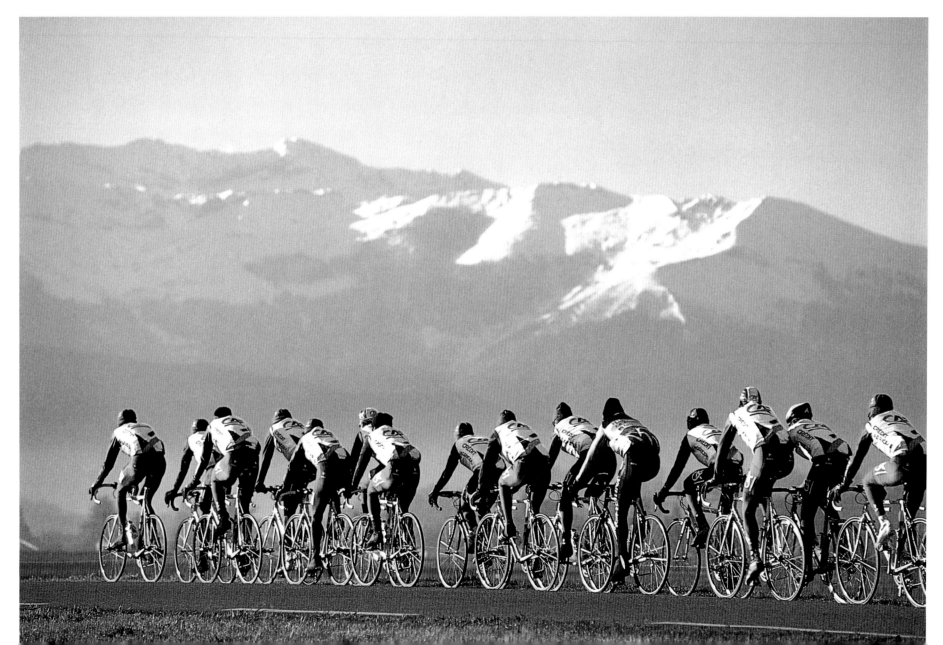

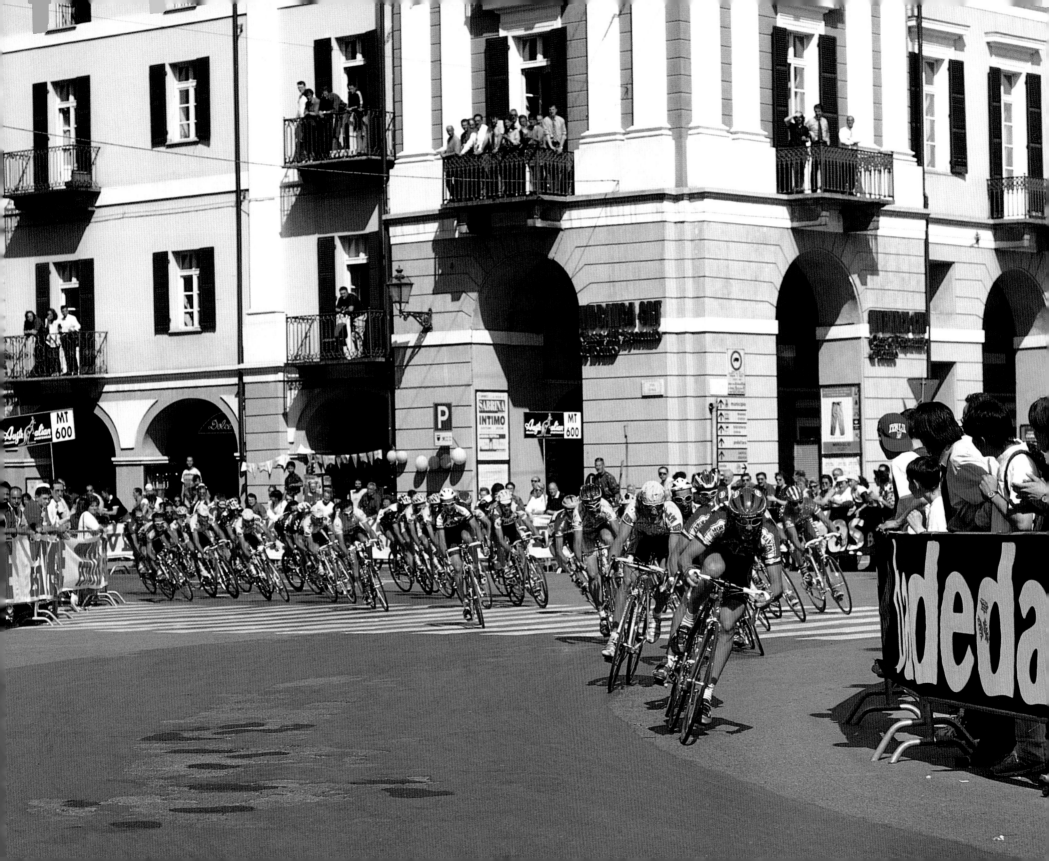

Left: **Giro d'Italia, Cuneo, 1997** There are just 600 metres to go to the finish line, and the delights of this pretty town square would be nothing more than a blur to the lead out men of Amore e Vita who are positioning Glenn Magnusson for victory. It seems an impossible task for the rider on the far right of the picture to avoid hitting the barriers, but there were no casualties on this particular bend. The people in the apartments overlooking the square have the best deal here. They would have been able to watch the race on TV as it approached Cuneo. As the peloton charged through the streets they can step outside on to their balconies to see it pass, before ducking back inside to watch the sprint taking place just down the road.

Right: **Giro d'Italia, Cervinia, 1997** Italians love their cycling heroes. I am envious that countries like Italy have a sport that creates such passion and interest, while in Britain cycling struggles to make an impression on the national consciousness. Here Ivan Gotti has attacked the Maglia Rosa on the road to Cervinia. It was a do-or-die effort and it worked for Gotti as he won the stage and took the race leader's jersey that he kept all the way to the finish. Normally I would try and get a clean shot of the first rider but on this occasion I also went for the do-or-die approach and chose a wide-angle lens that would involve both Gotti, his fans and the scenery to try and capture the whole moment in one image.

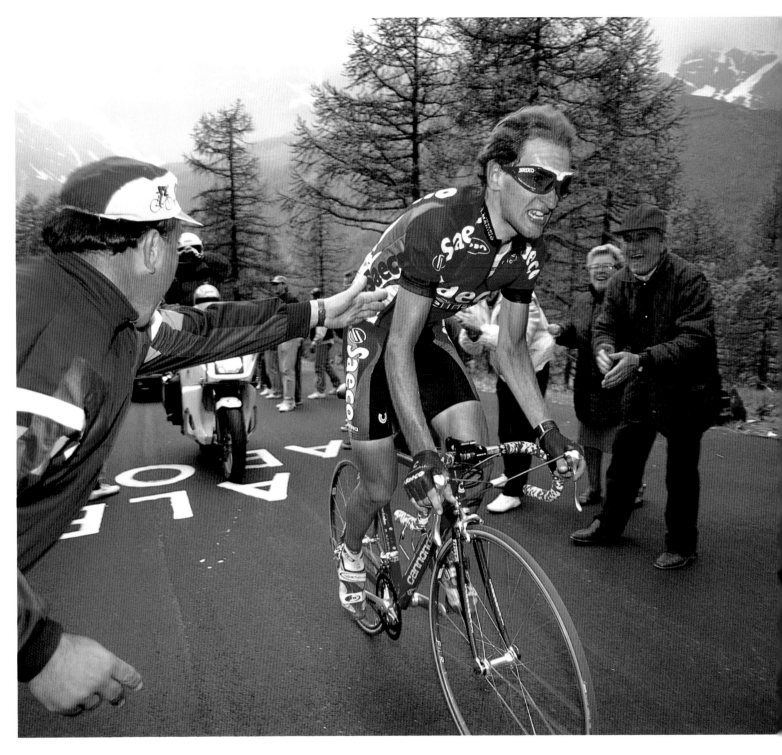

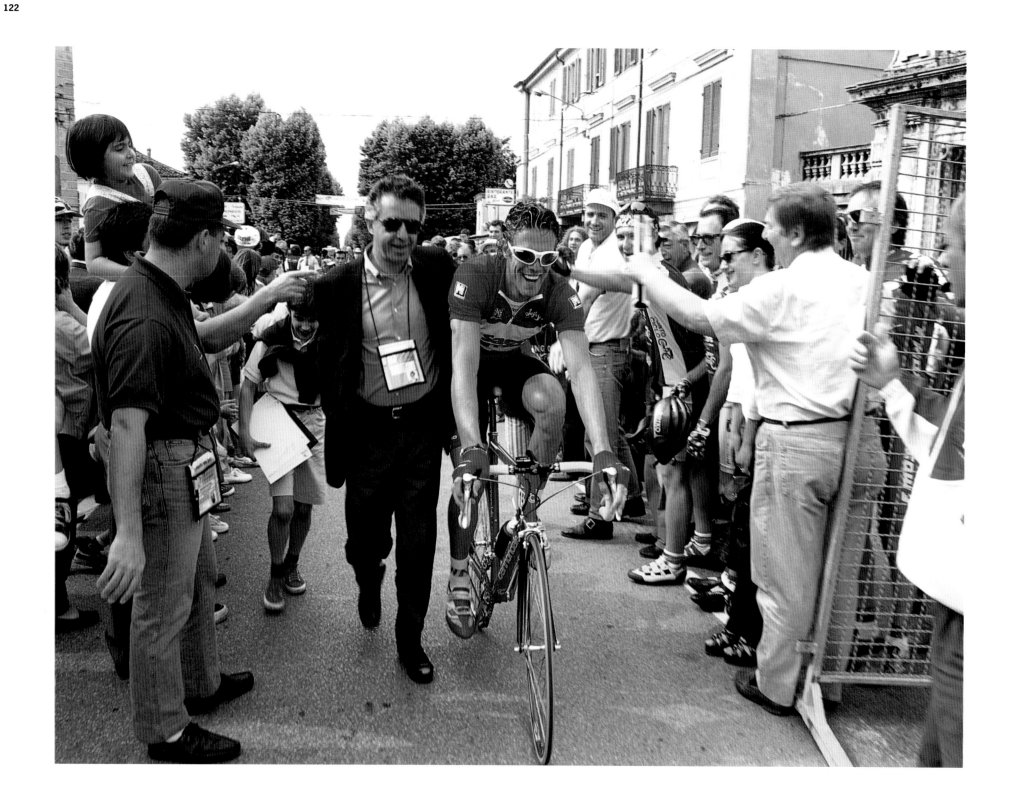

Left: **Giro d'Italia, 1997** I have chosen this image for the same reason as the Ivan Gotti picture. Mario Cipollini is a hero to Italian cycling fans, a larger than life character who always draws a crowd wherever he goes. Look at the faces of all those in the picture and it is clear that everyone is as pleased to see Cipo as he is to see them. Italians love their bike riders to be champions, but perhaps even more important, they love them to have style and a personality to match. Cipollini is the perfect example of such a rider.

Right: **Gianni Bugno, Tour de France prologue, Le Puy du Fou, 1993** Everybody loves a world champion, the rainbow jersey is instantly recognisable as something special. Here the cheering, clapping fans send the 1992 world champion Gianni Bugno – who also won the title in 1991 – on his way as he begins his prologue effort in the Tour de France. The previous year he had reached the podium but on this occasion he was destined for 20th place.

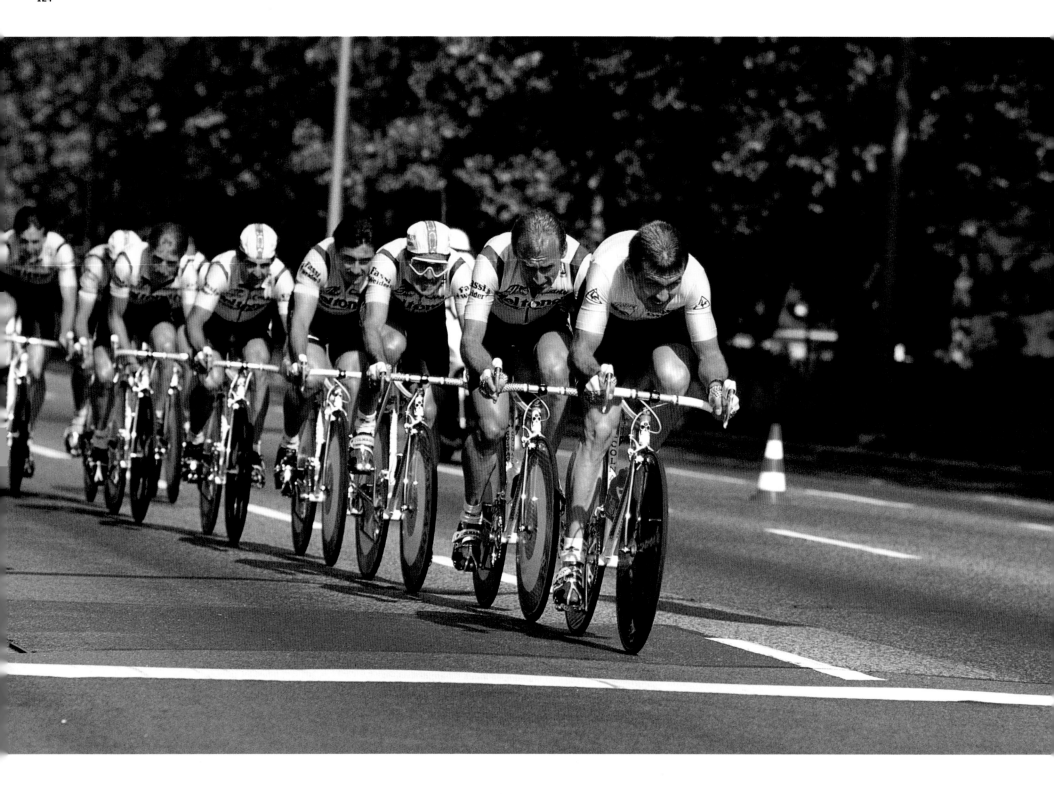

Left: **Tour de France, Berlin, team time trial, 1987** Lech Piasecki had taken over the yellow jersey after the morning road stage and was now able to lead his Del Tongo team mates, including Giuseppe Saronni in fourth spot, in a blaze of yellow. Nowadays they would be told to redesign their kit for the Tour as yellow team strips clash with the race leader's jersey.

Right: **Tour de France, Courcheval, 1997** This is one of those few views in the Alps that usually gives you a classic mountain shot with a bit of snow in the background, but it doesn't always work like that. Although Marco Pantani won here in 2000 in blazing sunshine, that day the mountains in the background were shrouded in cloud.

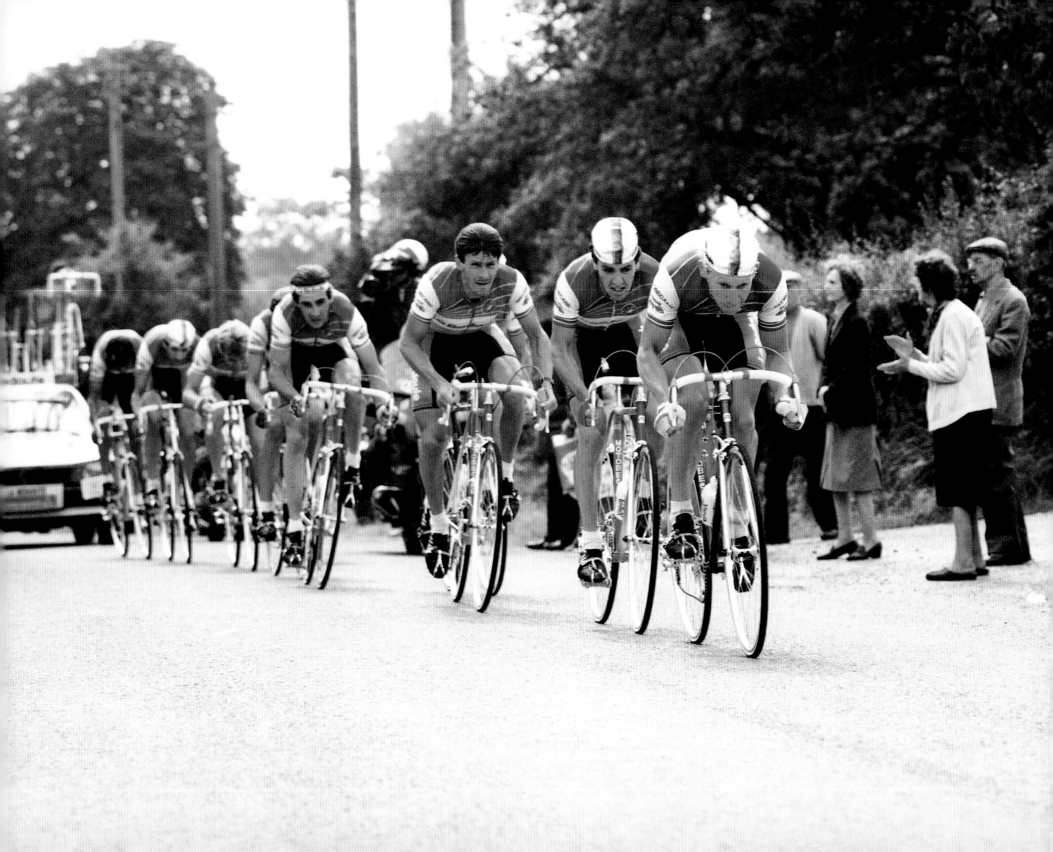

Left: **The La Redoute team, Tour de France, team time trial stage, 1984**

Étienne de Wilde leads Stephen Roche, Paul Sherwen and Alain Bondue. For years the TTT was an integral part of the Tour. The riders may not have always been great fans of the discipline, but the photographers have always liked it, as did the spectators. Chris Boardman is probably not a great fan, because if there had not been a TTT during the 1994 Tour then he would have worn the yellow jersey during the British stages.

Right: **Tour de France, Hampshire, 1994**

People still talk about the time the Tour de France came to England, and so they should. It was the most amazing two days for cycling in this country. Crowds of more than a million flocked to the roadsides on both days to experience Tour fever. The roads were closed, there were picnics, bands played and the pubs were open all day. The Tour organisers went home saying they were overwhelmed by the response of the British. For those of us who regularly go to France to see the race it was wonderful to be able to see so many more people experiencing the Tour for the first time.

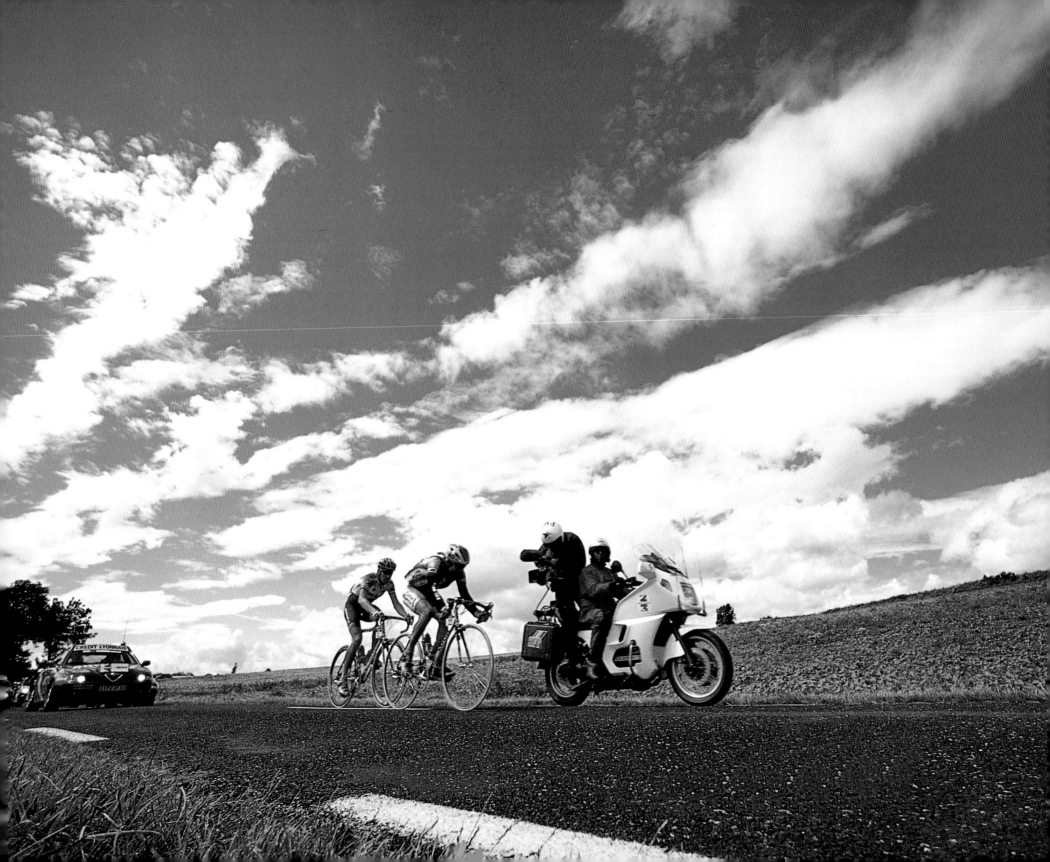

Left: **Tour de France, Bagnères-de-Bigorre to Revel, 2000** Erik Dekker and Santiago Botero attacked early and stayed away all day. Dekker won his second stage of the Tour and a week later the Dutchman made it three, giving cycling magazines and newspapers the chance to wheel out their 'Double Decker' and 'Triple Decker' headlines. The Dutchman has had a hard time as a pro, with bad luck and injuries keeping him out of the results. He also has an unusual double-armed victory salute, which resembles somebody maniacally knitting a jumper. I used a very wide-angle lens and got down low to try and capture the loneliness of these two riders as they battled to stay ahead of the peloton.

Right: **Tour de France, Germany, 2000** Just as when the Tour came to Britain it's arrival in Germany brought out the crowds in their tens of thousands. I was driving ahead of the race and when I crossed the border into Germany I was met with a sight that took my breath away. It seemed that everybody had turned out to watch the race. Every vantage point had been occupied for hours with people waiting to see the Tour arrive on German soil. I took this photo some way down the course on a small climb, hoping to show the size of the crowd. In the photo it is difficult to see where the riders stop and the crowd begins. In the end I did what most photographers do when all else fails – wave the camera around in the air and hope for the best. I think I got away with it this time.

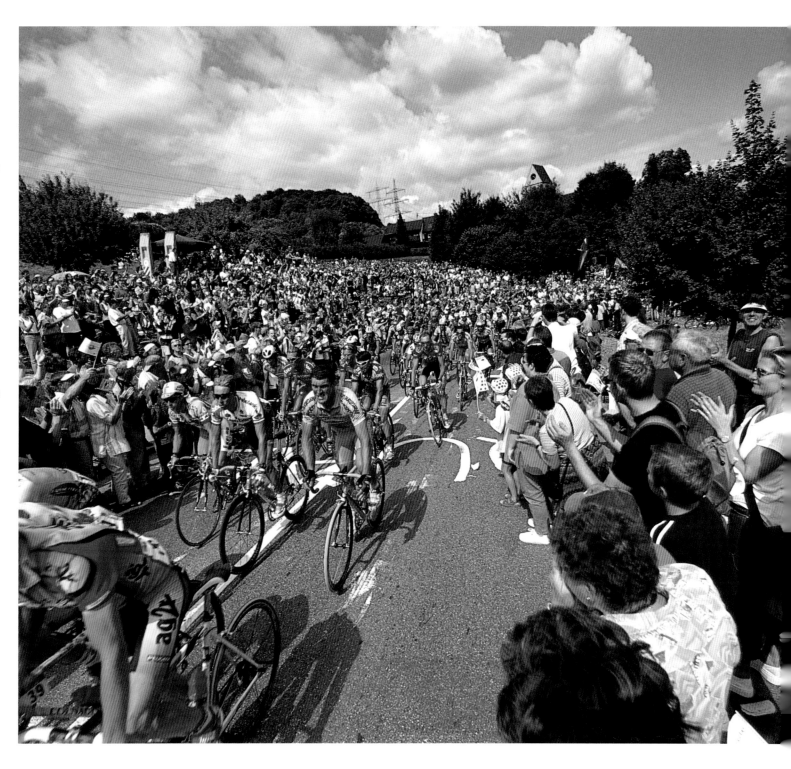

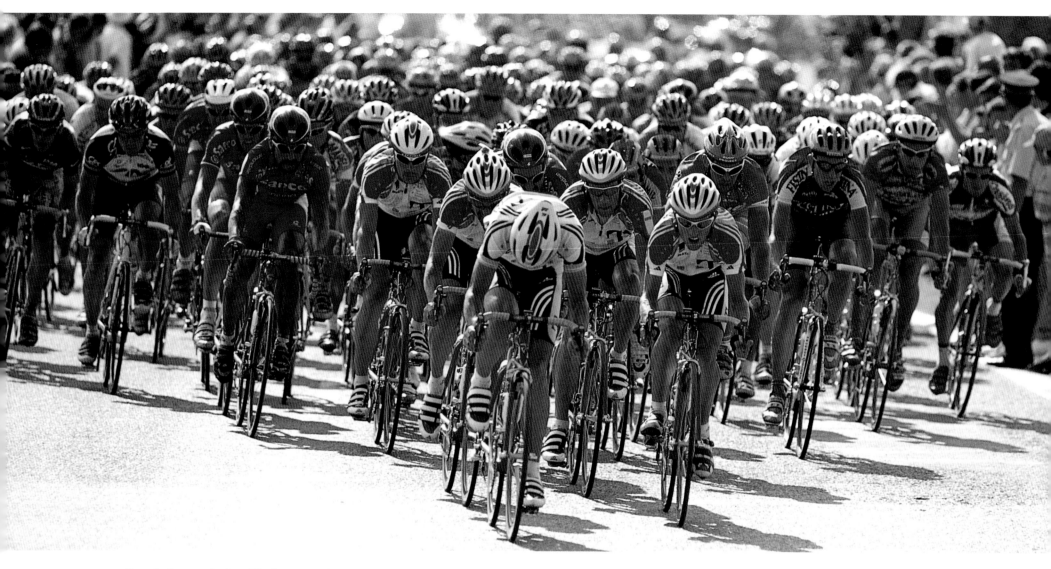

Above: **Tour de France, Amiens–Maubeuge, 1999** I took this photo with about 2 miles to go on a hot sultry afternoon. It shows the classic arrowhead formation as the Telekom team drive hard at the front preparing the sprint for Erik Zabel. All around them the Mapei and Saeco teams are trying to get their men in position for the sprint, while other riders like Stuart O'Grady are looking for an opportunity to strike. Tom Steels won the stage but was later disqualified for cutting across Jan Svorada in the final charge to the line. One of the reasons you rarely see pictures like this is that most photographers have already positioned themselves on the line ready for the final sprint. This picture captures all the tension and drama of sprinters like Mario Cipollini, Steels and Zabel, for whom these stages are some of the most important races of the year.

Right: **Tour de France, 1999** The problem with photographing the Tour is that you often get so caught up in the race and itís personalities that you forget to stand back and capture the event for what it is – a bike race in one of the most attractive countries in the world. On this day I decided to look for a picture that was typically French! This view suddenly hit me between the eyes after I had driven for miles down the course in this area of south western France. I bet if I had taken this picture 30 years ago, the buildings would look exactly the same, and if I were to return here in 2029 it would probably still not have changed. And there's a good chance that if you were to go into the boulangerie on the right thirty years from now, the owner would still make you a sandwich the size of a house brick that would leave you full for the rest of the day!

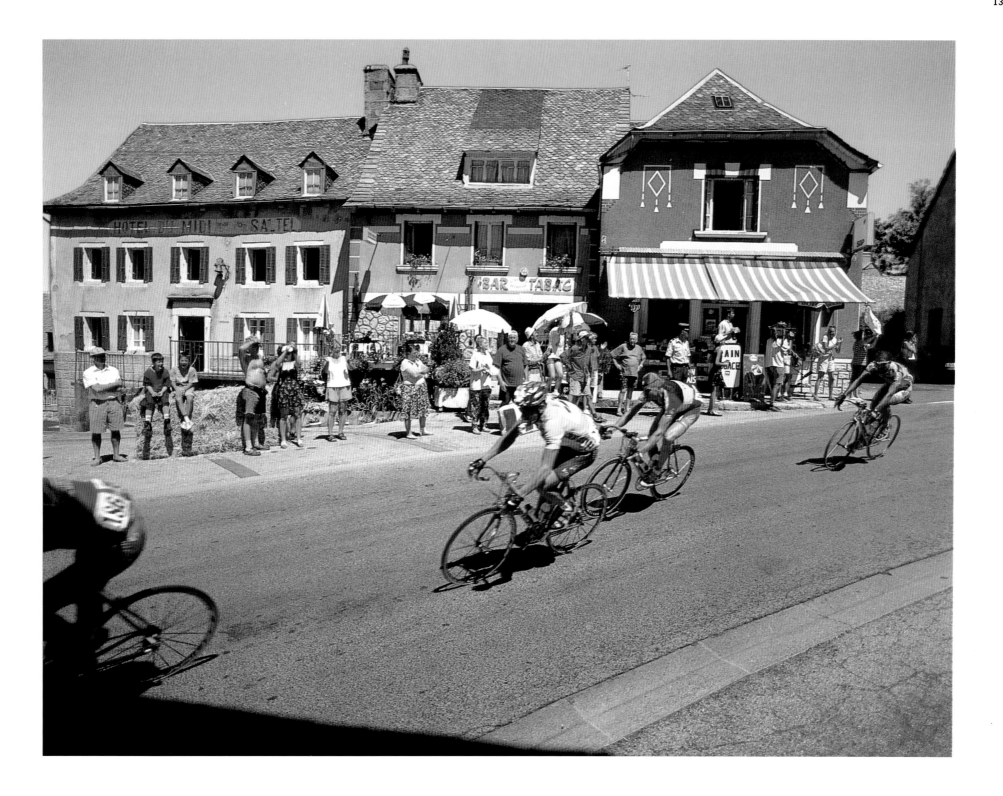

Index*

*This index features the main riders and personalities identified in the photos.